A–Z

OF

ILKLEY

PLACES - PEOPLE - HISTORY

Mark Hunnebell

AMBERLEY

Dedicated to the memory of Frazer Irwin, 1947–2022
Lateral thinker, horticulturalist, historian, thorn in the side of convention for over
seventy-four years and loyal friend. He will be greatly missed.

First published 2023

Amberley Publishing
The Hill, Stroud, Gloucestershire, GL5 4EP
www.amberley-books.com

Copyright © Mark Hunnebell, 2023

The right of Mark Hunnebell to be identified
as the Author of this work has been asserted in
accordance with the Copyrights, Designs and
Patents Act 1988.

ISBN 978 1 3981 0488 4 (print)
ISBN 978 1 3981 0489 1 (ebook)

British Library Cataloguing in Publication Data.
A catalogue record for this book is available
from the British Library.

Typesetting by SJmagic DESIGN SERVICES,
India. Printed in Great Britain.

Contents

Introduction

By means of introduction I feel it is only fair to state that this book does not pretend to be a fully comprehensive alphabetical record of all things Ilkley. To include an exhaustive 'list of everything' would of course require a substantially larger (and weightier) volume to the one you are currently holding.

The intention of this book is to provide further insight into the history of the town, through a useful alphabetical format. I hope it will be used in conjunction with and as a companion to my previous book *Secret Ilkley*, published by Amberley in 2019.

Because of constraints with the number of pages in *Secret Ilkley* some material had to be omitted – scope therefore for inclusion in this A–Z. The rise of Ilkley as a spa town in the nineteenth century is already well documented, so the development of the Hydros isn't covered in this book. What I wanted here was something of a move away from the familiar bread and butter stuff and for different items of interest to be recorded, as well as an opportunity to indulge some images from the family album and anecdotes too.

Curiosity no doubt arises as to what might be included under the letters 'Q', 'X' and 'Z'. In fact, these were easier to find than may be supposed. Entries under the letter 'I' proved much more difficult. At first glance it is perhaps assumed that with 'Ilkley' as the subject, 'I' would be the easiest category to fill. This is just the problem. There are too many potential entries, meaning the 'I' section could have accounted for around 95 per cent of the book, so this was trimmed down, allowing space for other entries elsewhere.

I have also included as many photos as I could to illustrate the text. As ever I am grateful to Sally Gunton and the *Ilkley Gazette* for use of images from their collections, though I have been able to use a good number of my own images too.

It has been a great pleasure compiling this book and I am very grateful to everyone who has bought a copy of this or any of my previous books. For me though financial gain isn't the prime objective; rather it is the satisfaction obtained from searching for, finding and then collating interesting facts, details and photographs of the physical and social history of Ilkley and being able to share them with like-minded people who also have an affinity with our town and an interest in what has gone before.

Read this book as you will, either cover to cover or (I suspect) in and out of the A–Z sections in no particular order. However you read it, I hope you enjoy it.

Mark Hunnebell, March 2023

Air Crash Memorials

There have been a number of aircraft crashes on the moors around Ilkley. During the Second World War a Canadian Air Force Halifax bomber crashed at Woodhouse Crag, to the south-west of the Swastika Stone, on 30 January 1944, killing all six crew on board. A memorial cairn was placed at the site in 2006 to mark the 62nd anniversary of the tragedy.

Just after the end of the war a Lancaster bomber, RA 571 of 429 Squadron based at RAF Leeming, also with a Royal Canadian Air Force crew, was similarly disorientated by low cloud and crashed near the summit of Beamsley Beacon around noon on Bonfire Night 1945. Four of the eight crew members on board were killed with one of the survivors, Sergeant Joseph Balenger, making it down the hillside in thick fog. The crash had been heard by residents nearby and they went out on to the hill, where they found the airman stumbling towards them. He was taken to Black Foss Farm, where

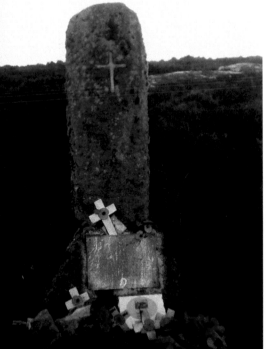

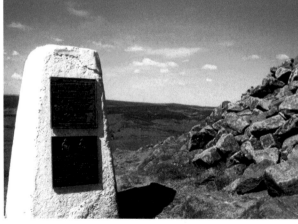

Above: Air Crash Memorial at the summit of Beamsley Beacon. (Mark Hunnebell)

Left: Air Crash Memorial at High Crag, Ilkley Moor. (Mark Hunnebell)

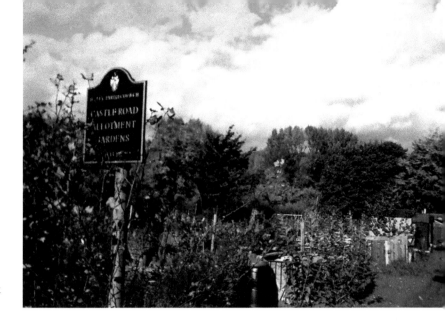

Castle Road allotments near the River Wharfe. (Mark Hunnebell)

help was summoned. Sgt Balenger was taken to the Coronation Hospital in Ilkley where he recovered from his ordeal. Having suffered no serious physical injuries, he was allowed to return to his unit later in the week. The other surviving crew members were also taken to the hospital but transferred to the emergency facility at High Royds, Menston, for further treatment as their injuries were more severe.

A plaque to commemorate those killed was placed on the old trig point marker at the summit of Beamsley Beacon in 2015 to mark the 70th anniversary of the crash.

Allotments

During both world wars people were encouraged to grow their own vegetables and keep chickens and rabbits with a view to being less reliant on national agriculture and imports of food. Areas of land adjacent to the river were given over to allotments. After the war some of these were retained and are still in use – though with less emphasis on chicken and rabbit. During the Second World War huts for a children's day centre were erected along Castle Road adjacent to the allotments. The huts were removed in the 1950s. Other allotments remain on Bridge Lane and between Leeds Road and the river near Backstone Beck.

Arcadia

A marquee entertainment venue on Wells Road, the 'Arcadia' was a popular summer attraction in the years prior to the First World War. In November 1912 part of the canvas structure was damaged by strong winds, but not beyond repair and it was ready again for the 1913 season. The site was later occupied by the Christian Science Church, now the Wells Road Business Centre.

Backstone Beck

Flowing down from the moor as one of the four main tributaries into the River Wharfe at Ilkley, Backstone Beck also marks the boundary between Ilkley and Ben Rhydding. Its journey of around 2 miles starts near the summit of the moor and flows across the bleak wide expanse of marshland then down into the steep valley past the Crocodile's Mouth Rock before passing under Hangingstone Road, Ben Rhydding Road, Clifton Road, Bolling Road, the railway, Valley Drive, Leeds Road and entering the River Wharfe near Beanlands Island.

Beanlands Island

For generations the banks of the river have provided an alternative playground to the moors for Ilkley's children, including Beanlands Island between the suspension bridge and the 'Toll Bridge'. In summer months the narrow channel between the south bank of the river and the island is easily crossed when the water level is low, but beware: after heavy rain the crossing isn't advised and during floods the island itself can become deluged along with parts of the riverside path at some points.

The source of Backstone Beck near the summit of Ilkley Moor. (Mark Hunnebell)

Beanlands Island – a place of outdoor adventure for many generations. (Mark Hunnebell)

Bonfire Night

During the First World War in 1916, the Defence of the Realm Act, known as 'DORA', came into effect. This prohibited the lighting of bonfires and the use of fireworks. Consequently Bonfire Night remained on hold for the rest of the war. When the Armistice was announced on 11 November 1918, coming only a week after another cancelled Bonfire Night, fireworks were much in evidence all over Ilkley – despite the ban still technically being in place a blind eye was turned to the revelry. It was reported, 'The pyrotechnic display in Brook Street was of a character never before attempted; nor would it have been allowed, DORA and the police were not to be met with in authority.'

Likewise during the Second World War Bonfire Night celebrations were put in abeyance for the duration of hostilities; though the end of the war was marked with beacons being lit on the surrounding hills. Who would have thought in 2016 when this photo was taken that just four years later Bonfire Night in 2020 would again be cancelled, this time due to Covid-19 restrictions?

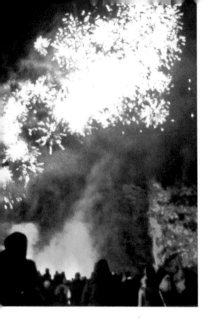

The Bonfire Night fireworks display at the Riverside Hotel, 2016. (Mark Hunnebell)

Brook Street

Brook Street is the main shopping street in the town, running north–south from the traffic lights. The stream flowing down the middle of the road was covered over in the 1850s and the culvert has been replaced periodically over the years.

The rise in the number of motor vehicles in the early decades of the twentieth century inevitably led to minor mishaps. During the First World War twenty-year-old Ilkley resident Clara Hunnebell got a mention in the local paper in July 1917:

> Clara Hunnebell, daughter of Mrs Hunnebell, Wellington Road, was knocked down by a motor car at the top of Brook Street about noon on Tuesday (10th) but fortunately was not seriously injured, although much bruised and shaken.

Fortunate indeed. Clara was to become my grandmother!

The fountain at the top of Brook Street features in a photograph taken on 5 March 1949. If we could walk into the picture and go along The Grove and around to the Grove Cinema we might be in time to see the film *No Room at the Inn* with Freda Jackson. Alternatively, we could go in the other direction down Brook Street and on to Railway Road to the New Cinema where *The Birds and the Bees* starring Jeanette Macdonald and Jane Powell was being shown. Incidentally the New Cinema became the Essoldo cinema in mid-March 1949 – only a couple of weeks after the photograph was taken.

The 'Bunny Run'

This was the colloquial name given by Ilkley youths in the 1940s to their town centre gatherings. Teenagers would meet up in Brook Street and walk one way or the other

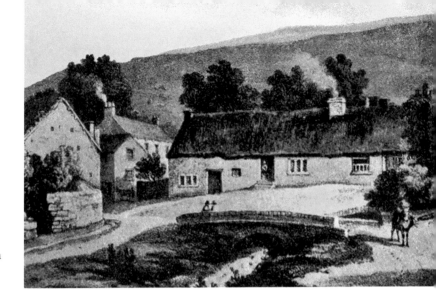

Impression of the top of Brook Street in the early nineteenth century. (Sally Gunton)

around the square formed by Brook Street, Church Street, Cunliffe Road and The Grove, returning to their starting point. As the groups crossed over at each half-circuit banter and jocularities were exchanged. No trouble arose from this activity though whether residents appreciated gaggles of giggling girls and bunches of boisterous boys wandering around the town centre streets in the early evening is not recorded. This we must remember is the same era that saw complaints raised by residents about 'Boogie-Woogie' music emanating from the 'Feast' held annually on land behind the Wheatsheaf pub adjacent to New Brook Street. The 'Bunny Run', although perhaps irritating to some of the more sedate residents living around the town centre, was by and large partaken in an atmosphere of quaint innocence.

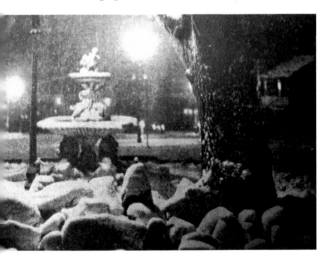

Above: The 'Monkey Rack' Fountain after heavy snowfall, 1949. (*Ilkley Gazette*)

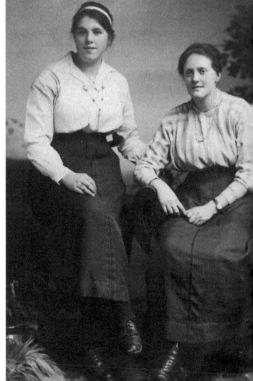

Right: Sisters Lucy (left) and Clara Hunnebell, *c*. 1917. (Mark Hunnebell)

Cattle Grids

In 1951 a meeting of local farmers discussed the possibility of providing fencing to stop sheep wandering into the town centre from the moors. It was ultimately decided that cattle grids would be an effective and convenient method to solve the problem. These were installed in due course and continue to safeguard the town's public and private flower bed – providing pedestrians remember to close the gates alongside ... oops!

Cemetery

The Ilkley Cemetery opened on ground adjacent to the river in the 1870s. The parish church's burial ground was somewhat small and quite full. With the ever-growing population of the town and the addition of other churches, it was necessary for alternative provision to be made. So the cemetery with its two chapels was created by the Ilkley Local Board.

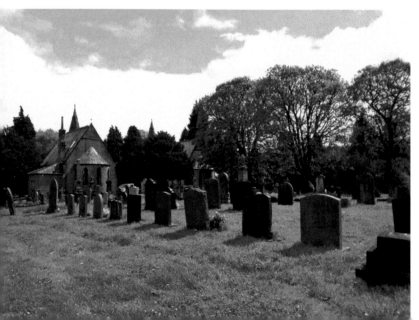

With population expansion the Local Board provided the cemetery in the 1870s. (Mark Hunnebell)

Cenotaph (Correction)

In our book *Ilkley and the Great War* Caroline Brown and I state that the Ilkley cenotaph was unveiled on Sunday 22 July 1922 and the hymn 'O God Our Hope in Ages Past' was sung. It was in fact unveiled on Sunday 23 July 1922 and the hymn 'O God Our Help in Ages Past' was sung. Apologies for these unintended typos that have come to my attention.

Christmas

Particularly white ones. There were fifteen white Christmases recorded in Ilkley between 1869 and 2022 – around 10 per cent. These were: 1869, 1870, 1874, 1876, 1878, 1890, 1895, 1899, 1906, 1923, 1927, 1938, 1956, 2009 and 2010. Note: this data concerns Ilkley and the immediate local area, not nationally. In some years of course snow has been recorded in other parts of the country (if snow falls *somewhere* in the UK it is defined as 'white') while around here there was none. Christmas 2021 was declared 'white' under this rule though frustratingly, snow fell in the Ilkley area in the early hours of Boxing Day – a day too late. There were near misses in some other years too with 1887, 1917, 1918, 1919 and 1950 being reported as having snow on the moors but not in the town. While in 1935 there was thawing slush on the streets and in 1956 the snow didn't start falling until the evening of Christmas Day.

What of the fabled 'Winter of '47'? Christmas 1946 was green; the heavy snows fell in January 1947 and lasted around two months. At the other end of the year snow fell again – though three days too late for a white Christmas. Similarly in 1981, Christmas was green but by New Year's Eve there had been heavy snowfall.

More recently 2009 and 2010 saw the first time since 1869 and 1870 that there was a white Christmas in consecutive years.

An article on the changing climate was published in the *Ilkley Gazette* in 1900:

Our Climate. Of late years the winters for the most part have been particularly mild, and this has led many people to imagine that some change in the temperature of our climate is gradually taking place. In past ages we know changes of temperature took place sufficient to transform the regions of perennial flowers and foliage into vast areas of ice cold desert wastes, and for what some of us know to the contrary, this evident change of temperature may simply be a continuance more or less regular, of the change from cold to warmth and warmth to cold that our climate has previously experienced. Popular opinion at any rate seems to be inclining to some such belief, though scientific calculations may not possibly bear out any such hypothesis.

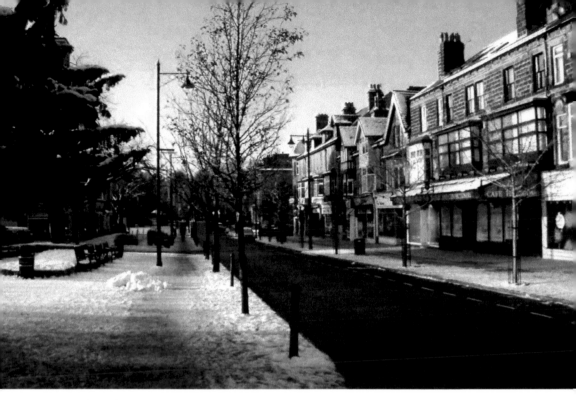

A rare white Christmas Day in Ilkley town centre, 2009.

It seems the concept of 'climate change' has been around for a little longer than we might previously have thought. But we can still (secretly) continue to hope for a little 'nonno-bobbo' every Christmas!

A dramatic event occurred in Ilkley at Christmas in 1913. The *Ilkley Gazette* reported,

> Shortly before noon on Christmas Day, a horse belonging to Mr W. Whitaker of Ilkley, and attached to a landau, bolted from the front of St Margaret's Church, Ilkley. Thomas Johnson, the coachman, was about to leave the church with three ladies, when the horse took fright and dashed along at top speed down Queens Road, Wells Road and into Brook Street ...

Despite the best efforts of the driver, the horse crashed into the iron palings near the station. He was thrown from his seat and the horse required veterinary attention while

> Mr William Swallow of Trafalgar Road, who was proceeding along the footpath with his umbrella up, had this smashed, and only just dodged the carriage as it was overturned. The ladies had to be taken out of the carriage.

Fortunately, nobody suffered any serious injury and the ladies, although shaken by their experience, were alright. Let's hope that Mr Swallow's brolly hadn't been a Christmas present!

Church Street

The building that gives its name to the street is the parish church of All Saints on the north side of the road adjacent to the traffic lights at the junction of Brook Street, New Brook Street and Leeds Road. Built on part of the former Roman fort site of 'Olicana', the Church was established here in AD 627 and evolved over the centuries; with considerable rebuilding undertaken in the early 1860s. More recently the interior of the church was improved in 2019 with the removal of the wooden pews to allow more flexibility with seating and a new entrance with a covered link to the adjacent church hall was constructed.

The five-panelled east window of the church, depicting a scene of the Crucifixion, dates from the renovations of the 1860s. It was given to the Church by Mr John Margerison and the glasswork was created by Mr W. Warrington of Bradford.

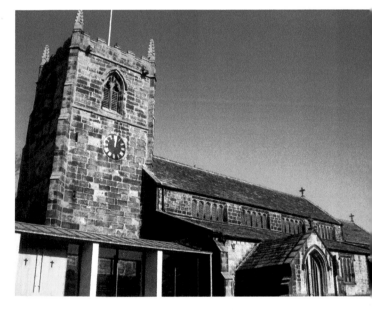

The parish church of All Saints, 2020. (Mark Hunnebell)

Looking west along the ancient thoroughfare of 'Kirkgate' (Church Street) c. 1900. (Sally Gunton)

The three Saxon crosses that had stood outside the church were moved inside in 1983 to prevent further erosion completely destroying them – seventy-seven years after this move to preserve the stones was suggested in 1906. The central cross was largely restored in 1914 by sculptor Mr G. W. Milburn of York.

Church Street, or 'Kirkgate' as it was sometimes referred to, forms the main route west from the town along the A65. The photo looks west towards Skipton Road. Improvements at the east end of Church Street were made in the early years of the twentieth century, which involved the demolition of the old 'Star' and the creation of New Brook Street. Church Street was also the location of the Wheatsheaf pub on the corner of New Brook Street. The pub was demolished in 1962. On the south side of Church Street opposite the church is the Black Hat pub, previously the Rose and Crown, with a long history and believed to be one of the oldest pubs in Ilkley, though largely rebuilt around the end of the nineteenth century.

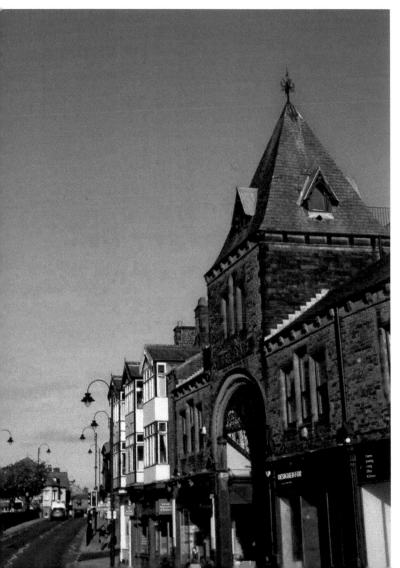

Looking east along Church Street, 2022. (Mark Hunnebell)

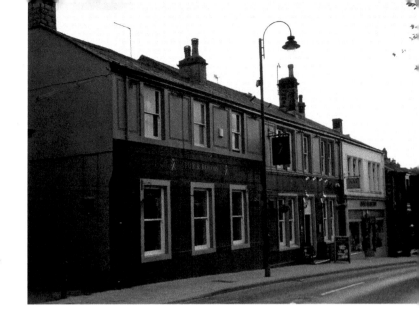

The Black Hat pub, formerly the Rose and Crown. (Mark Hunnebell)

Conker Hill

This is the steep incline connecting Wheatley Lane with Ben Rhydding Road, colloquially named after the profusion of horse chestnuts to be found here during the autumn months. The adjacent houses around High Wheatley now occupy the site of the former Ben Rhydding Hydro, demolished in the 1950s.

'Conker Hill' raises Wheatley Lane steeply up to Ben Rhydding Road. (Mark Hunnebell)

Coronavirus

During the lockdowns of 2020 and 2021 the town centre was eerily quiet with only essential food shops, chemists and the Post Office open. People queuing stood socially distanced 2 metres apart and spoke in hushed whispers, if at all.

While this might be a common collective memory of life in lockdown, the fact was in some rural areas visitor numbers approached that usually found on Bank Holidays. The interpretation of 'daily exercise' was taken by some to include driving to places such as Ilkley Moor particularly during the fine spring weather of both years.

A memorial to local victims of the pandemic was installed in Paradise Park adjacent to the Old Bridge in 2021. This also commemorated those who helped in the local community during this time. It was officially dedicated in a ceremony held on 3 July 2022.

Above: During the Covid-19 lockdowns the town centre almost felt post-apocalyptic. (Mark Hunnebell)

Left: Visitors came in large numbers to the moor for 'daily exercise' during lockdown. (Mark Hunnebell)

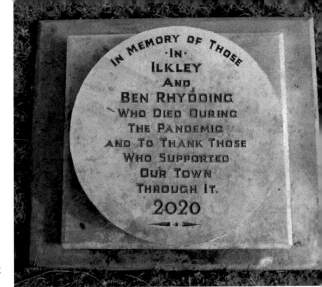

IN MEMORY OF THOSE
·IN·
ILKLEY
AND
BEN RHYDDING
WHO DIED DURING
THE PANDEMIC
AND TO THANK THOSE
WHO SUPPORTED
OUR TOWN
THROUGH IT.
2020

The Memorial Stone in Paradise Park to local victims of the pandemic. (Mark Hunnebell)

Coutances

In 1947 the Ilkley Grammar School arranged for a French exchange group to come from Coutances for three weeks in Ilkley. When they returned home a delegation of pupils from Ilkley went back with them for two weeks. The French students enjoyed their time in Ilkley, while for the Ilkley students in France, their visit was something of a novel experience. There was still much evidence of the Second World War. Burned-out tanks and broken military equipment littered the countryside.

In 1969 Ilkley was formally twinned with Coutances and exchanges between the two towns have taken place regularly since. The A65 to the east of Ilkley has been named Coutances Way in recognition of this.

The A65 to the east of Ilkley is named Coutances Way. (Mark Hunnebell)

Cow and Calf

The familiar rocks overlooking Ben Rhydding have been a popular attraction for visitors since the middle of the nineteenth century.

The nearby Highfield Hotel had been established around the turn of the twentieth century and although not a 'Hydro', it was popular with walkers and visitors to the Cow and Calf Rocks. It was sold in 1948 and became the familiar Cow and Calf Hotel still popular today.

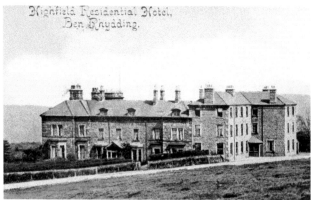

Above: The Cow and Calf Rocks provide a panoramic view over Wharfedale. (Mark Hunnebell)

Left: The nearby Highfield Hotel – familiar today as the Cow and Calf Hotel. (Mark Hunnebell)

Crocodile's Mouth

The prominent local landmark the 'Crocodile's Mouth' is best viewed from the wooden bridge across Backstone Beck on the footpath between the Tarn and the Cow and Calf Rocks.

The 'Crocodile's Mouth' overlooks Backstone Beck on Ilkley Moor. (Mark Hunnebell)

Crum Wheel

The 'Crum Wheel' is popular with visitors during the summer months but during winters past it was renowned for the 'Ice Wheel' that formed on this section of the River Wharfe. The bend in the river at this point creates very strong undercurrents and as the ice on the frozen river cracked a 'wheel' could be seen rotating on the surface.

Visitors are reminded of the old dialect adage: 'Wharfe gans swift; Aire gans lithe; where Aire droons one; Wharfe droons five.' Many wise locals are aware of the potential dangers the 'Crum Wheel' poses and avoid going in the river here.

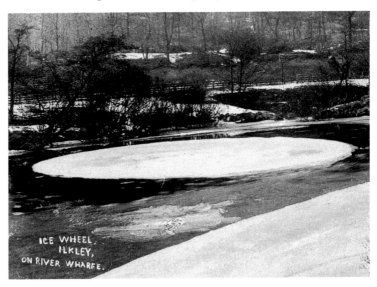

The great 'Ice Wheel' – a rare sight on the Wharfe at Ilkley. (Sally Gunton)

Diesel Trains Introduced on Local Lines

At the beginning of 1959 passenger steam trains on the local lines to Leeds and Bradford were withdrawn. The change had been anticipated for a while beforehand but due to delays with the manufacturers of the new trains the start date had kept being put back. The diesels cut the travel time to Leeds by four minutes and Bradford by five minutes, taking just over half an hour for the journey to either city. The steam train drivers underwent re-training (quite literally!) to operate the new diesels while

Now consigned to museums, 'DMUs' were once familiar on the Wharfedale Line. (Sally Gunton)

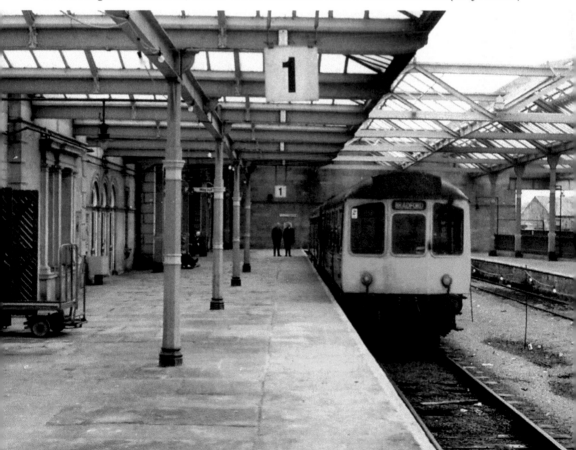

the former footplate firemen were transferred to other depots as their jobs on the Wharfedale Line became obsolete. The *Gazette* article informing readers of the change finished with a question about a steam locomotive: 'Does anyone want to buy an engine? – The one at Ilkley is for sale.'

Distance Marker

Every day many commuters and visitors passing through Ilkley railway station walk underneath the distance marker on Platform One. It announces that King's Cross station is 211 ¼ miles away.

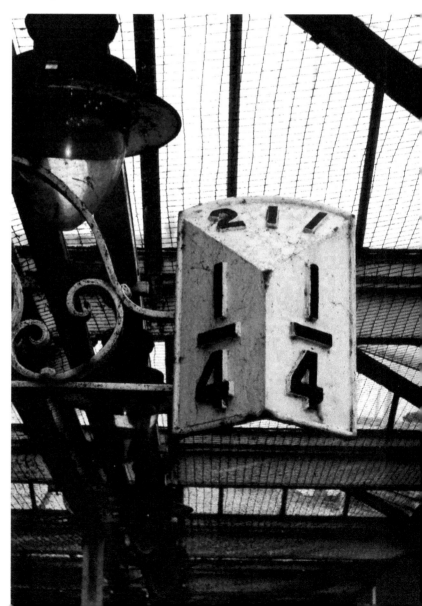

The distance from Ilkley to London King's Cross displayed on Platform One. (Mark Hunnebell)

'Duck Neb'

A much-passed feature in Rocky Valley on the moors, 'Duck Neb' is the name given to a rocky outcrop at the western approach to the valley. It appears in turn of the twentieth-century era photographs, usually with someone sat on the prominence seemingly high above the ground. 'Duck Neb' is still there but its quirky old name has by and large been forgotten – I recall this feature being referred to in my childhood as the 'Alligator's Mouth' as opposed to the 'Crocodile's Mouth', the familiar local landmark overlooking Backstone Beck.

Dustbins

Compulsory dustbins were introduced relatively late – in the 1930s. The Health Committee of Ilkley Council 'decided that a notice should be inserted in the local newspaper stating the council's intention to require the provision of dust bins in lieu of ashpits after December 31 [1937] and advising the owners and occupiers of property concerned to provide dust bins before that date'.

One of the councillors, Mr Voight, was curious to know who should take responsibility for providing the bins: the landlord or the tenant, from where the bins would be available and at what cost? The answers being that bins were available from Ilkley Council at a cost of eleven shillings and sixpence each and as to the responsibility for providing them, the chairman announced, 'The Clerk has just informed me that we can serve the notice on the owner, the landlord or the occupier.' So not providing a definitive answer and raising a matter of debate between landlords and tenants!

Six decades later in the 1990s the issue of bins was in the local news again. This time it was the introduction of 'wheelie bins' causing the controversy. Households had to put the bins out on the street themselves ahead of waste collection. Inevitably letters to the *Gazette* on the topic were plentiful!

'Duck Neb' provides a great photo opportunity in Rocky Valley, Ilkley Moor. (Sally Gunton)

E

Eclipses

Astronomical events seen from the UK often have a frustrating tendency to be marred by cloud, though solar eclipses have occasionally been memorably witnessed. In June 1927 Ilkley got a very good view of the eclipse, almost total as seen from the town with the moor being a popular destination; likewise for the August 1999 eclipse. For the partial eclipse at the spring equinox in 2015 the event was witnessed through cloud, which provided an opportunity for some interesting photographs. The next total eclipse to be seen in the UK will occur on Saturday 23 September 2090. I wonder what the weather will be like ...

The partial solar eclipse on the spring equinox, 2015. (Mark Hunnebell)

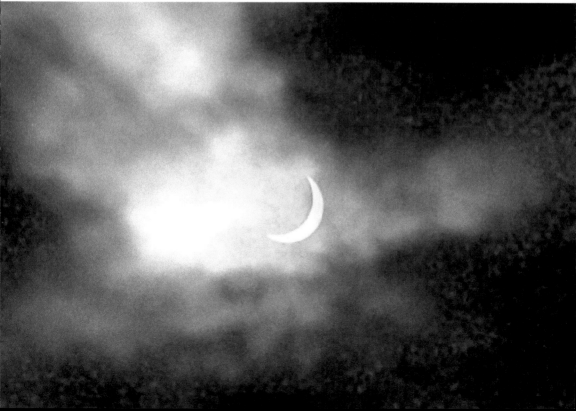

Electric Trains

The Wharfedale Line was electrified in the 1990s – quite an undertaking both financially and logistically. Engineering and building work to modify the line took place often at night to minimise disruption to the rail services to Leeds and Bradford. However, the idea of electrified railways had been around for some time. Almost seventy years before the arrival of electric trains in Ilkley the *Gazette* featured articles on them in 1926 and 1927. The idea was generally well received and thought to benefit both locals and visitors, but the council 'Learnt that this was not a practical thing at all', due to expense and the likelihood of investment in roads instead and it was thought by the time electrification was complete trains may have become obsolete.

Talking of electrification, the first electric car charging point in Ilkley was installed in the town's central car park in 2020.

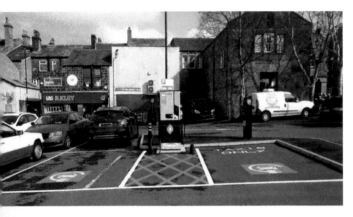

Ilkley's first public electric car charging point was installed in 2020. (Mark Hunnebell)

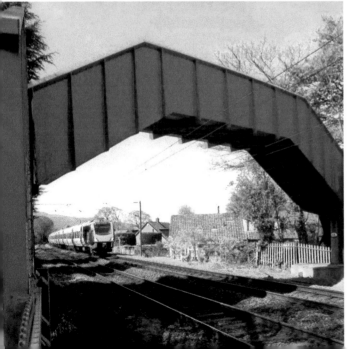

A Bradford-bound train approaching 'Angel Bridge' between Ilkley and Ben Rhydding. (Mark Hunnebell)

F

Fairy Dell

A little-visited feature in the locality, 'Fairy Dell' sits below the dam of March Ghyll Reservoir on the northern slopes of the valley and is bordered by farmland to the west, south and east with open moorland to the north. A public footpath runs through the dell linking Middleton with Denton. This tinted picture pre-dates the construction of March Ghyll Reservoir.

'Fairy Dell' on the north side of the valley near March Ghyll. (Sally Gunton)

The former fire service hut in the grounds of 'Abbeyfield', Riddings Road. (Mark Hunnebell)

Fire Service Hut (Abbeyfield)

During the Second World War the summerhouse in the grounds of the Convalescent Home was used by the Ilkley Fire Service and ARP. It was considered expedient to use young lads as messengers to convey notes between the hut in Riddings Road and the fire station in Golden Butts Road.

Football on Motorbikes

An eccentric twist on 'the beautiful game' was reported in 1924 when the Ilkley and District Motorcycle Club entered a footballing competition played on motorbikes. Ilkley were beaten 6-0 in the final held as part of the Ripon carnival, Ilkley having beaten York 'B' in the qualifiers at Otley the previous week. Needless to say, the 'sport' didn't flourish. The ground staff at the venues would certainly have been kept busy, particularly during wet weather!

G

Grammar School

Established in 1607 to provide a rudimentary education, the school was originally located on Skipton Road. In the 1870s a purpose-built 'National School' was opened on Leeds Road catering more broadly for the basic educational requirements of Ilkley's children, while in 1893 the new Grammar School, only accepting boys, opened in large purpose-built premises on Cowpasture Road where it is still based today – although much extended since. At the start of the twentieth century the school had its own rifle range and in 1913 the swimming pool was built. In 1939 girls were admitted to the school for the first time though girls' education had been provided through many private schools in Ilkley since the nineteenth century and following the post-war restructuring of education the school became part of the comprehensive system but retained the 'Grammar School' title.

The 'New' Grammar School opened on Cowpasture Road in the 1890s. (Mark Hunnebell)

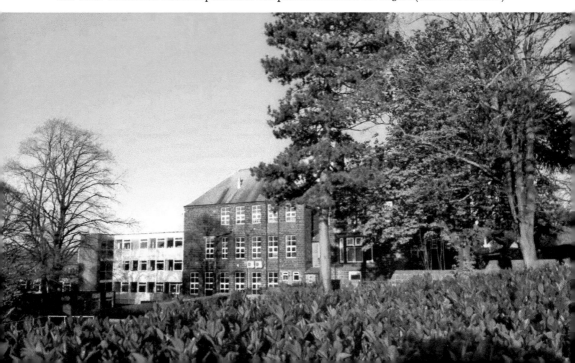

The Grove

The Ilkley Charity Hospital and Grove Hotel were built on the south of Green Lane in the early 1860s. Following the land sales later in the decade the former Green Lane was redeveloped. The elegant parade of shops on the north side of the road was built in the late 1860s and early 1870s, forming Ilkley's premier shopping street. On the south side the Congregational Church and the buildings between Riddings Road and Wells Walk were erected.

In the 1880s verandas above the shops at the eastern end of The Grove at the corner with Brook Street caused consternation. This was resolved by the removal of the support pillars which were perceived as an encumbrance to pedestrians and instead the verandas were suspended from above by struts fastened to the exterior wall of the building.

In the 1920s an area of ground at the junction of Parish Ghyll Road opposite the Canker Well was considered for the construction of a petrol station catering for the rise in motor transport. This was rejected and following the council's purchase of the land it was instead laid out as a park and opened in time for Easter 1933.

The elegance of The Grove has always been complemented by fine tea rooms. The Kiosk Café and the Café Imperial were very well patronised during the early years of the twentieth century, the former becoming a branch of the ever-popular Bettys in 1962. In 1930 The Bluebird Café opened in the Spa Buildings and became a regular meeting place for many groups and organisations in the town. The other shops along The Grove have changed use over the years. The grocery shops have all gone and 'Masons', later 'Daltons', butchers on the corner with Brook Street is now a jewellers.

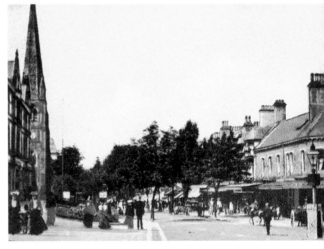

Above: A colour-tinted photograph of The Grove around 1900. (Sally Gunton)

Left: The glass verandas above shops at the eastern end of The Grove. (Mark Hunnebell)

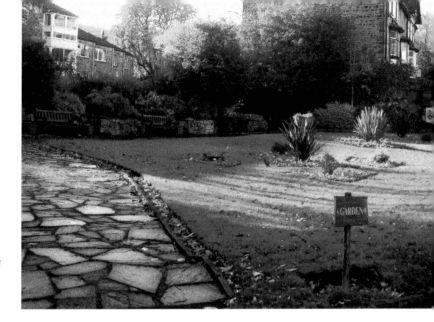

The small park proves more aesthetically pleasing than the proposed petrol station! (Mark Hunnebell)

Another at No. 42 is the shop previously known as 'The Grove Jewellers'. This was managed by Tove Vestergaard, a familiar figure on The Grove in the 1980s. Sadly Tove passed away in 2005, but she will be long remembered for her effervescent personality and sense of fun – and personally as the best boss I've ever had.

In 2001 the bandstand on the south side of The Grove was completed. A Millennium project, the bandstand provides an ideal town centre location for public entertainments – a long-awaited replacement for the former bandstand demolished in 1948 that had stood in West View Park (now Darwin Gardens Millennium Green) on Wells Road. Another twenty-first-century innovation was the introduction of the 'Jubilee Lights' in 2012. The Grove has usually been decorated for the Christmas

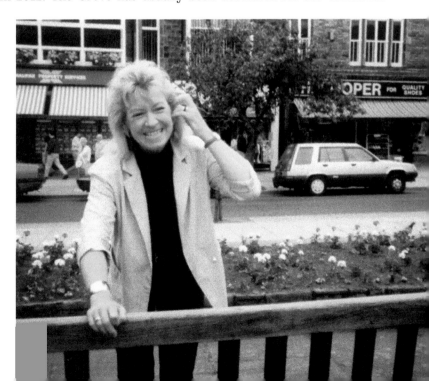

Tove Vestergaard photographed on The Grove in June 1989. (Mark Hunnebell)

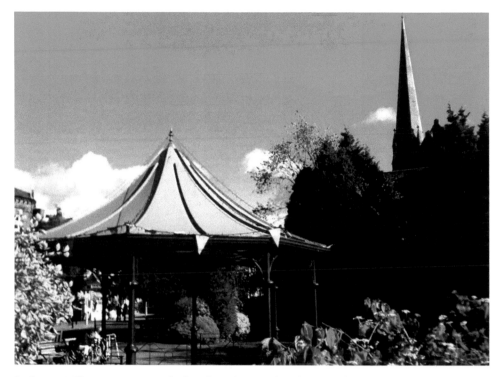

Built as a Millennium project, the bandstand was officially opened in 2001. (Mark Hunnebell)

season – and the autumn illuminations of the 1930s. Now the modern lighting provides a much-appreciated year-round feature.

In 2014 anticipating the Tour de France's Grand Depart around Yorkshire, which passed through Ilkley, the town's Cycle Club held the inaugural Town Centre Cycle Race. This has become an annual fixture in the calendar. The races are held on a

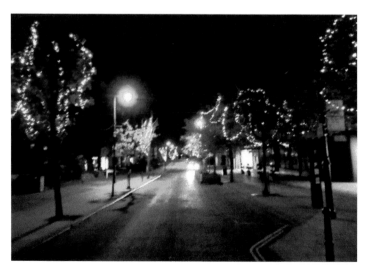

The tree lights are a year-round feature – not just for Christmas. (Mark Hunnebell)

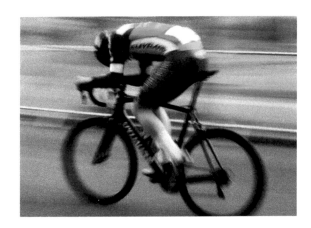

The town's annual cycle races are a popular summer evening event. (Mark Hunnebell)

summer's evening starting and finishing on The Grove. The circuit heads from The Grove, up Riddings Road, along Albany Walk, Parish Ghyll Drive, down Wilton Road, along Grove Road and back onto The Grove. The event attracts entries from across the region, often including some well-known names.

Grove Road Park

Another small park came into being in 1948. In February it was announced, 'A new public garden has been presented to Ilkley by the executors of the late Mr J. C. Crowther. It is situated at the junction of Wilton Road with The Grove.' This park continues to present a quiet space on Grove Road away from the town centre.

The park along Grove Road was created after the Second World War. (Mark Hunnebell)

Heber's Ghyll

Black Beck has its source at Heber Moss high on Ilkley Moor from where it makes its way down to the Wharfe, passing through Heber's Ghyll and past Hollin Hall en route. In 1887 the *Ilkley Gazette* speculated that Heber's Ghyll was named after Reginald Heber (1783–1826), Bishop of Calcutta, though it pre-dates this with family connections going back much earlier – a branch of the Heber family came to the Ilkley area in the early seventeenth century. In 1638 they moved from Austby north of the river to Hollin Hall on the south. The family is mentioned by the Revd Dr Robert Collyer and J. Horsfall Turner in their 1885 work *Ilkley Ancient and Modern*:

> It is generally believed that the Hebers of Hollin Hall were ancestors of Bishop Heber ... but it is not true. Bishop Heber was of the line of Thomas Heber, of Marton, brother of the first Reginald Heber, of Ilkley, so they are of the same blood, but not of the same descent. The line separates when Reginald comes to Ilkley in 1619, and never touches again.

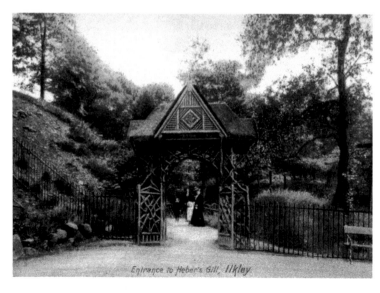

An ornate sylvan entrance gate once stood at the bottom of Heber's Ghyll. (Sally Gunton)

Heber's Ghyll has been a popular place to visit since Victorian times. In 1883 a chalybeate (iron water) spring was found at the top of the ghyll and a drinking fountain installed.

In 1928 there was a suggestion to run a bus service from the town to the bottom of Heber's Ghyll, but this met with considerable opposition from residents along the route and the plan was dropped. Today there is a convenient bus service around the residential streets of Kings Road, Grove Road and close to the bottom of Heber's Ghyll, though the future of this remains a cause of concern.

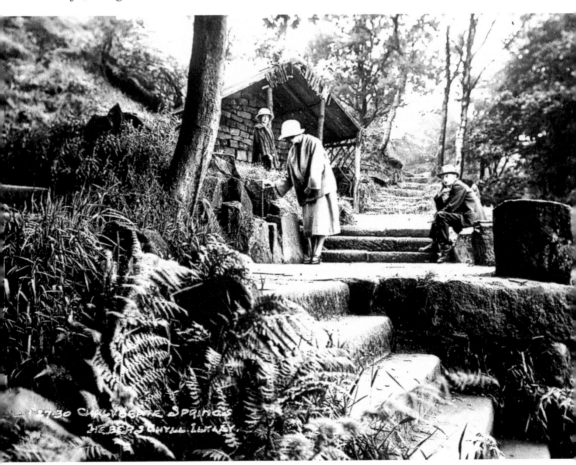

The chalybeate spring at the top of Heber's Ghyll in the 1920s. (Sally Gunton)

Ilkley

At the time of the 1841 census, in June of that year, Ilkley was already a popular destination. The temporary increase noted in the town's population was explained thus:

> Ilkley is a place celebrated for the salubrity of its air, the purity of its water and the beauty of its romantic scenery in consequence of which it is much resorted to in the summer months by all classes of the community.

Now, more than 180 years later, although water 'cures' may no longer be fashionable, Ilkley's popularity in summer endures with the moors, river and, since 1935, the Lido.

Illuminations

In 1931 as part of the national 'Faraday Centenary' the Ilkley Urban District Council arranged for prominent buildings in the town to be illuminated as well as installing some set pieces on Grove, including the famous Peacock. A direct descendant of the peacock became a familiar part of the town's Christmas lights until relatively recently

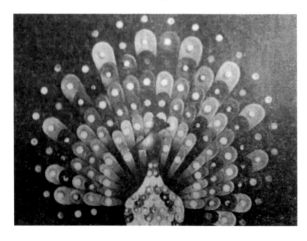

The illuminated Peacock on The Grove was always a popular feature. (*Ilkley Gazette*)

and was annually situated on the traffic island at the top of Brook Street. (It would be nice to see it return in the festive seasons.)

Inventions

In 1937 the *Ilkley Gazette* featured a photograph of a mysterious-looking machine along with its creator, Mr William Bradley of Addingham. He had won the 'Gold Yorkshire Medal' under the terms of the will of the late Mr Hoffman-Wood of Addingham, for the best non-war invention of the year. The device was developed for the weaving industry but it was suggested the technique could have other applications too:

> It was particularly intended to control the warp in a loom and to maintain tension at an even rate automatically from the beginning to the end of the beam. Since then, however, it has been applied to the lifting of a car and is even being designed to work in connection with the delicate control required in the tuning of a wireless set.

The model of Mr Bradley's invention was displayed in a shop window along Leeds Road while the medals he won for it were displayed in the window of Hill's jewellers in Brook Street.

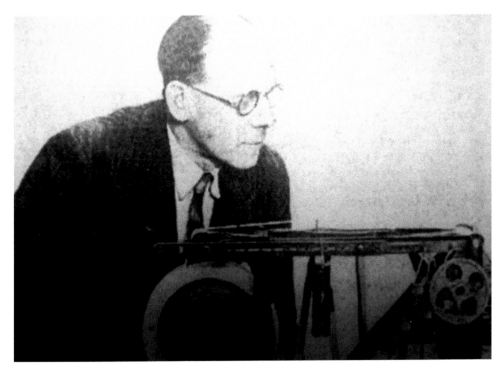

Mr William Bradley demonstrating his innovative equal tension device. (*Ilkley Gazette*)

Jewish Refugees

As persecution of Jews and minorities in Nazi Germany increased during the 1930s concerned residents in Ilkley wanted to do what they could to help. In 1938 a committee was formed with a view to helping refugee children and teenagers being evacuated from mainland Europe. Accommodation was sought and the Loxleigh youth hostel based in a house in Mount Pleasant off Cowpasture Road was secured for the purpose. The first refugees – Jewish boys aged between fourteen and sixteen – arrived in early 1939. Education was provided at the Ilkley Grammar School while the older boys went into farming or engineering. Some were able to reunite with other family members accommodated elsewhere in the UK.

A blue plaque was presented to the former hostel, now a private house, and an oak tree planted in the nearby Belle Vue Park on Cowpasture Road on 27 January 2022 – Holocaust Memorial Day.

The spiritual needs of the boys and that of the small Jewish community in Ilkley was provided for with synagogue services in the Masonic Hall and occasionally in the Wells Road Assembly Hall. (With gratitude to Nigel Grizzard for sharing information and his knowledge of this subject.)

As the Second World War started it wasn't only European refugees who found sanctuary in the town. Children from Leeds were also evacuated to Ilkley to escape the threat of air raids and were billeted with local families. Some of the evacuees returned to Leeds at weekends to see their relatives, somewhat defeating the object of the exercise and causing anger with their hosts, who were quick to point out that evacuation was not intended as a holiday and that the children's mothers were effectively delegating responsibility for their own onto someone else. Perhaps in hindsight Ilkley was a bit too close to home for some of the evacuees from the local region.

Ilkley has a good record of helping those escaping conflict. During the First World War Belgian refugees were welcomed and Vietnamese 'Boat People' found sanctuary in Ilkley in the 1970s. The town's tradition of hospitality continued more recently with the arrival of Ukrainian refugees in 2022.

The Jewish refugees were commemorated with an oak tree in Belle Vue Park. (Mark Hunnebell)

'Joint Exhibition'

Appearing in the *Ilkley Gazette* just two days before the Jimi Hendrix gig at the Troutbeck in March 1967, an advert for a 'Joint Exhibition' (an unintended pun?) piqued my sense of humour – this reference being from the 1960s and all. Of course, further investigation revealed that far from being something akin to an Amsterdam coffee shop, it turned out to be a collaboration between the library services and 'Safety in the Home' promoted by the Sandoz company of Horsforth. Somewhat ironically the details of the 'Joint Exhibition' were reported in the following edition of the paper next to and overshadowed by the columns devoted to the premature end of Hendrix's appearance in the town!

Jubilee (1935)

In early May 1935 King George V celebrated his Silver Jubilee. Events all over the country marked the occasion and Ilkley was no exception. The newly built open-air swimming pool provided the backdrop to the town's celebrations. There were also

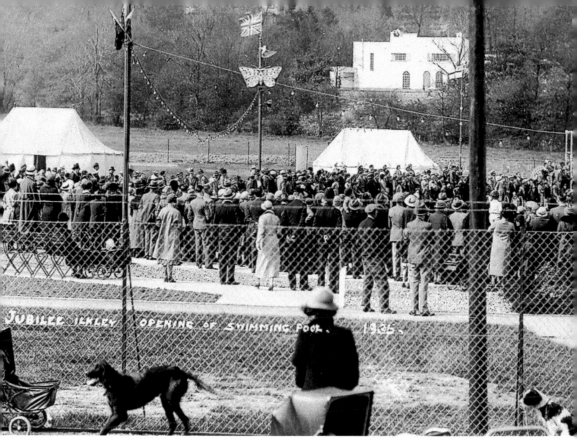

The Lido's opening coincided with King George V's Silver Jubilee in 1935. (Sally Gunton)

sports on the adjacent East Holmes field following a large procession that passed through the town centre. This photograph was taken of the crowd at the opening of the lido.

The weather for the Jubilee weekend had been good – sunny and warm conditions were reported, and people were out and about in their summer clothes, despite the apparent popularity of coats and jackets in the photograph! A couple of weeks later the weather took an unexpected turn, causing the local press to report, 'the snowstorm began this morning [17 May] shortly after 7.30 and the roofs and roads were quickly covered'. Readers were also informed, 'It is not often that cricket matches are cancelled owing to snow, but this seems a likely possibility for tomorrow.'

The cricket pitch was covered with 3 inches of snow, putting Ilkley's season opener in doubt. In the event a rapid thaw and a bit of frantic pitch clearance ensured the match went ahead, though they may have been better cancelling the game – Ilkley were beaten, losing to Otley by four wickets.

K

Keighley Gate

Marked as 'Whetstone Gate' on OS maps, Keighley Gate is situated near the summit of Ilkley Moor. There is a physical gate to open before descending down into the Aire Valley.

In 1911 the view from Keighley Gate was described in the local newspaper: 'Mr Bateson B. Rayner, says the writer of "cycling notes" in the "Yorkshire Evening Post", has been on his iron horse over the moorlands'. From a position near Keighley Gate taking in the sweep of the view north he suggests,

> Looking eastwards, and working along towards the west, the following landmarks were discernible: Howardian Hills, Hambleton, Great Almscliffe, Little Beamsley, Beacon, and Simons Seat, Great and Little Whernside, Penyghent, Blackstone Edge, and Pendle Hill.

The article concludes:

> The Cow and Calf everybody visits. Fine as the view is up and down the dale, it is not comparable with that from the Keighley Gate, which comprehends both Airedale and Wharfedale. It is five miles from Ilkley to Keighley.

The road down into Riddlesden is tarmac while the 'road' in the other direction back down into Ilkley which passes 'Cowpers Cross' close to Keighley Gate remains a rough track until as far back down the moor as Silverwell Cottage. A 4 × 4 vehicle or a horse, iron or otherwise, is recommended, though the easiest mode of transport remains 'shank's pony'.

The ancient route over the moor to Ilkley passes through 'Keighley Gate'. (Sally Gunton)

Leeds Road

The main route into Ilkley from the east is designated as the A65. Before the arrival of the railway in 1865 a coach service connected Ilkley to Leeds via Otley, with the large Ilkley Hydros offering a coach service to Arthington station on the Harrogate line. After 1865 the railway dominated until the twentieth century and the rise of motorised transport. The photo shows Leeds Road *c.* 1900s. Evidence of horse transport can be seen in the street, while a cyclist heads into town. I wonder what he would've made of the 'Grand Depart, Tour de Yorkshire' and Cycling World Championship races that have passed through the town in recent years, attracting huge crowds of spectators along the routes.

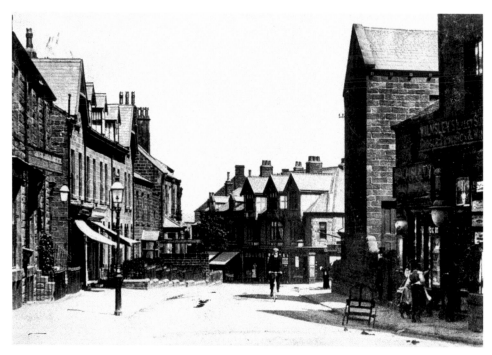

Leeds Road. While quieter than today, the buildings remain familiar. (Sally Gunton)

March Ghyll Reservoir

March Ghyll Reservoir is situated on the lesser-visited moors to the north of Ilkley above the farms of Middleton. Initially suggested in 1892, it was envisaged that the reservoir would provide a supply of water not to Ilkley but to Otley 6 miles/10 km down the valley to the east. It took another decade before construction started in 1902 and a further five years to complete. During construction, Charles Bellerby was blinded by a blasting cartridge and a benefit concert was held for him in Ilkley in May 1904.

The reservoir was a considerable undertaking, necessitating a temporary 'village' of tents and huts to accommodate the navvies. As the work progressed the Ilkley Angling Club anticipated there would be good fishing at March Ghyll in the years to come. This was reported in the *Ilkley Gazette* in the spring of 1907, shortly before the reservoir opened:

> The reservoir having only recently been completed, some may wonder what there is to catch. The Ilkley Angling Club, however, two years ago began to prepare for the future sport by turning 5,000 yearlings into the becks supplying the reservoir; and these should now provide somebody with a little diversion while many of the young fish in the club's rearing ponds will very shortly be transported thither.

Readers were further informed that the fish already in the reservoir were Loch Leven trout from Solway while the ones about to join them from the rearing ponds were brown trout, which can grow to a considerably larger size. Incidentally, the rearing ponds established by the Ilkley Angling Club in the 1880s were located in Terrace Ghyll, an area of woodland off Owler Park Road to the north of the golf club and below Middelton Lodge. These are on private land and cannot be accessed by the public.

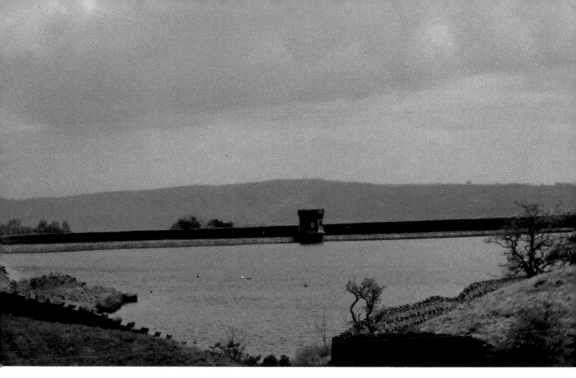

March Ghyll Reservoir above Middleton, with Otley Chevin in the distance. (Mark Hunnebell)

Middelton/Myddelton Lodge

The familiar Elizabethan landmark of Myddelton Lodge on the north side of the river was built on or close to an ancient settlement called Scalewray. No evidence of this exists at surface level today. The lodge was the property of the local landowners, the Middelton family, until the 1890s.

Hidden away in a secluded spot in the woods behind Myddelton Lodge is a contemplative garden ornamented with Christian iconography representing the Stations of the Cross and Crucifixion and consequently named Calvary. The garden was laid out in the shape of a cross in the early years of the nineteenth century by Peter Middelton, the son of the then Lord of the Manor, William Middelton. The Middeltons were a Catholic family and used this part of their grounds as their private meditative retreat.

In the early twentieth century it was reported Calvary was in a poor state of upkeep – and not included in the tenancy of Sidney Kellett, by then resident at Myddelton Lodge. It was further suggested that Calvary could prove lucrative: 'It would pay anyone to rent the place and make it presentable, for the number of people who visit Calvary during the summer is very considerable and a penny charge for admission would amount to a good sum annually.'

Calvary survived but became somewhat more dilapidated. In a letter to the local press in 1919 the condition of the place was lamented in that petty vandals had 'outraged all sense of decency and sacredness by cutting their initials' into some of the stonework.

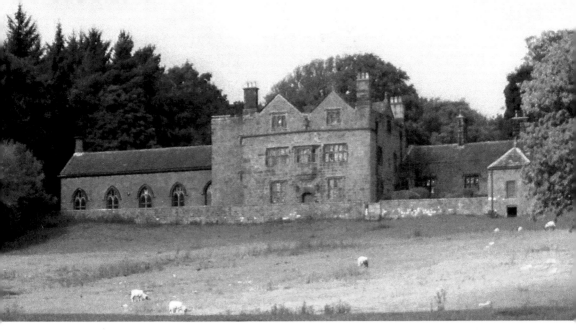

Myddelton Lodge – The former home of the principle local landowning family. (Mark Hunnebell)

In 1922 Middelton Lodge was sold to the Passionist Fathers and became a retreat, 'the monastery' becoming the familiar local and often still used name for Myddelton Lodge. In the late 1940s another representation of the Crucifixion was erected at the top of Lodge Hill by the entrance to the monastery. It was described as a 'Wayside Calvary' with visitors apparently coming from near and far to admire it – and it is still there; although relocated to the north of the entrance.

Myddelton Lodge was transferred into the Catholic Diocese of Leeds in the mid-1980s and at the start of the twenty-first century was sold. A youth retreat, Myddelton Grange, was built close to where the former monastery buildings had been. Though the Grange is now hired out as holiday lets

The original Calvary in its secret garden location still survives and has been cleared of non-native species of shrubs. It continues to provide a place of quietude for those of any faith or none in its peaceful woodland setting.

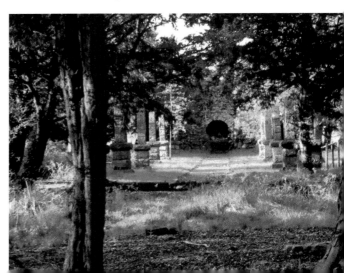

'Calvary' behind Myddelton Lodge provides a peaceful sanctuary for contemplation. (Mark Hunnebell)

Middleton Woods

Comprising Coppy Wood, Stubham Wood and Hudson Wood, Middleton Woods is the general collective term for these three separate but adjoining areas of woodland to the north of the town and the river. The woods were opened to the public during the 1920s, having been purchased by Ilkley Council, though in the 1930s some acres were controversially sold for housing. Coppy Wood on the north side of Curly Hill was the last area opened up, donated by Arthur Hentzen in 1937 as a coronation memorial to King George VI. The woods are currently managed by Bradford Council.

A brilliant display of spring bluebells in Coppy Wood. (Mark Hunnebell)

Milestone

The milestone near to Myddelton Lodge suggests the distance to Rippon is just 15 miles!

The question of dubious distances on old milestones was noted by the *Ilkley Gazette* over a century ago, in 1916, in an article called 'The Lying Milestones':

> There are some old milestones that gave such distances from place to place as to deserve this title, and in reference to several it has been applied. Two or three in the locality of Middleton and Nessfield give distances to Otley, Ripon and elsewhere that are astounding.

The article goes on to state,

> How those who erected the stones arrived at the distances given would be interesting knowledge, but it is said that the old time constables were responsible for this work and possibly with some of these distances might be the result of rough local calculations, and calculating distances with most country people is distinguished for anything but accuracy.

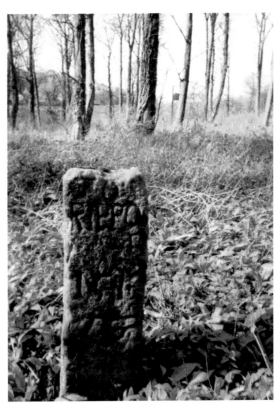

The milestone at Middleton gives an optimistic 15 miles to 'Rippon'! (Mark Hunnebell)

Mill Ghyll forms a picturesque 'green corridor' from the town centre. (Mark Hunnebell)

Mill Ghyll

Leased to the town in 1872 by William Middelton, Mill Ghyll provides a 'green corridor' between the town centre and Queens Road on the way up to the moor edge. The corn mills that stood in the ghyll were demolished and bridges were built over the stream instead. Water was also collected from here, being piped down to the railway station to supply the boilers of the steam engines.

Moor Golf Pavilion

Opened in 1898, the moorland golf course stretched westward from the Keighley Gate road across towards Heber's Ghyll. In June 1906 the clubhouse was broken into but a passing policeman on his beat, PC Smith, was alerted to what was going on and fought with the intruders. The *Ilkley Gazette* gave a dramatic account of the proceedings:

At the Otley Police Court on Monday William Taylor, a navvy working at March Ghyll waterworks, and who appeared with his head bandaged, was charged with breaking into the Ilkley Moor Golf Clubhouse early on Sunday morning.

The police constable's account of the event was reported:

> Smith said he was passing the golf club house shortly after midnight, when he observed that the door of the ladies' dressing room was open. A closer inspection showed him that force had been used, as the lock was broken. He also saw that the window of the gentlemen's dressing room was smashed. Turning on his lamp he observed two men crouching on their knees, and he at once asked them what they were doing.

In the resulting struggle the constable was able to draw his truncheon and apply it to one of the intruders, but PC Smith was knocked to the ground and had his whistle grabbed from him and thrown away. He was also hit in the chest with a stone and indicated to the court that he was speaking with some difficulty. The chairman advised him to take his time in recounting the events.

> Ultimately he managed to secure Taylor but the other man got away. He conveyed Taylor to the Police Station, having on the way the assistance of PS Will.

Taylor's companion was arrested the following morning but,

> owing to his condition it was deemed advisable to take him to the hospital. Taylor gave an excuse that he was drunk. He was remanded for a week.

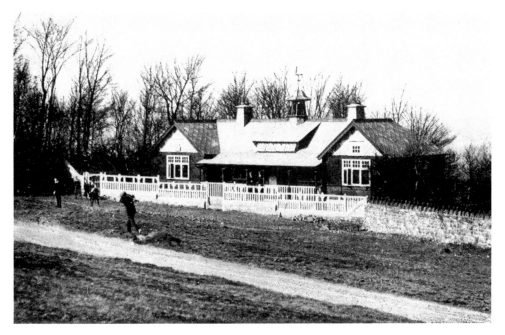

The moor golf pavilion – scene of a vicious struggle in 1906. (Sally Gunton)

Moorland Fires

Fire, both accidental and deliberate, is a constant danger to the moors and its habitats during the dryer months of the year. Glass from broken bottles has always been a common cause, as reported in 1951. The accompanying picture shows the efforts being undertaken by visitors to Rombalds Moor with fire beaters attempting to put out a large blaze that had broken out on the top and was heading towards Burley Moor.

> Another result of the hot sunshine has been an outbreak of moor fires. Some of these undoubtedly have been caused by the action of the sun's rays on the many broken bottles to be found on the moor. One was caused by the carelessness of campers, who are not supposed to be on the moor at all. A more serious cause of what was the most severe outbreak of a series on Sunday is reported to be the deliberate action of three youths. This fire caused the attention of three brigades for over three hours before it was brought under control. There is sufficient danger with the old bracken as dry as it is, without fires being started deliberately, and if offenders are traced steps should be taken to bring them before the Justices.

Over the years there have been some spectacular fires. Most recently the large one at Easter 2019 caused considerable concern. Fire beaters are still used today, though of course in conjunction with miles of hosepipes, water backpacks and in the case of the 2019 fire, a helicopter to collect water from Panorama Reservoir to drop on the flames. Despite the destruction caused, the moor is surprisingly resilient and within a few weeks green shoots had once again started to reappear and the moor was beginning to regenerate. The dire predictions that the recovery would take at least a decade were somewhat pessimistic. Within two years the summer bracken was back with a vengeance!

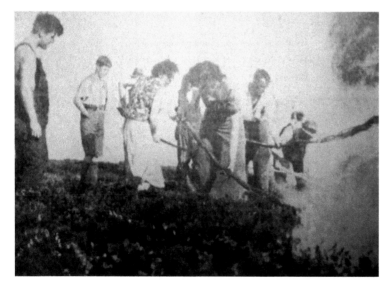

Members of the public helping to fight moorland fire, 1951. ('Ilkley Gazette')

Nell Bank

It was suggested in 1928 that the large detached house at the east end of Hudson Wood on the north side of the river could be used as a maternity hospital. The idea never came to fruition and Nell Bank remained in Ilkley Council's possession until it was demolished somewhat controversially in 1973. In 1977 the site was redeveloped into the Nell Bank outdoor pursuits centre as a project to mark the Queen's Silver Jubilee. Over the course of more than forty years Nell Bank has been extended considerably and continues to be a popular venue for schoolchildren from all over the Bradford District.

Nesfield

The small hamlet of Nesfield, 2 miles or so to the north-west of Ilkley and below Langbar, was the subject of a debate in the early 1950s as to the correct spelling of its name. Evidently during the interval of a concert a local vicar caused controversy with his remarks and the matter saw the light of day in the *Ilkley Gazette.* The paper reported at length on the vicar's comments that the correct spelling of Nesfield

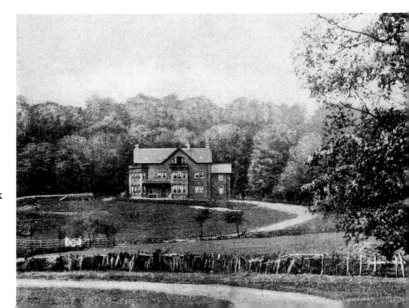

The former Nell Bank House on the edge of Hudson Wood. (Sally Gunton)

should be by use of two 's's', i.e., 'Nessfield', and that to spell the name with only one 's' was 'new-fangled'. The *Gazette* responded to this claim by citing an example of the spelling with one 's' on a map dated 1777 held in the Ilkley Library archives. Further, that the Ordnance Survey uses the one 's' spelling, as did many official bodies at that time. However it also acknowledges the use of two 's's' by Robert Collyer among others in their written works. The article points out that there are also different spellings of Middleton and Ilkley and 'To return to old time spelling of place names would lead to endless confusion' and concludes, 'but for administrative and business purposes there must be recognised and official spellings Ilkley, Middleton, Nesfield'.

So the matter was clarified, or so thought the *Gazette*, because the spellings of Nesfield and Middleton continue to vary to this day! (And the paper used the double 's' spelling itself in an article years earlier – see the entry 'Milestone'.)

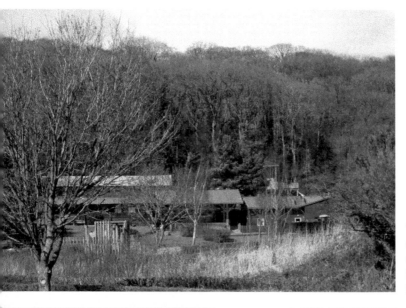

The Nell Bank outdoor pursuits centre occupying the same site today. (Mark Hunnebell)

The 'Postman's Shelter' in Nesfield – a good stop for lunch! (Mark Hunnebell)

O

Olicanian's Cricket Pavilion

In my book *Secret Ilkley* I touched on the various sports clubs in the town. The 'Olicana' or more correctly the 'Olicanian' cricket club (my apologies) dating back to the 1920s got a passing mention. While *Secret Ilkley* went to print another chapter concerning this club was being written. Over the August Bank Holiday weekend of 2019, as the England cricket team were about to embark on a remarkable comeback in the Ashes series at Headingley, the Olicanian's pavilion was destroyed in a night time arson attack. The community rallied and a new pavilion was completed in 2022.

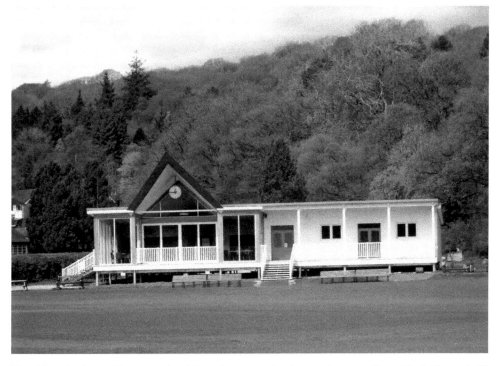

The Olicanian's pavilion – a splendid replacement for the previous pavilion. (Mark Hunnebell)

On Ilkla Moor Ba'ht 'At Plaque

Yorkshire's most famous tune, 'On Ilkla Moor Bah't 'At', isn't a local composition, though the lyrics were improvised by a visiting Sunday school group, it is believed, in the 1880s. It has been pointed out that the tune was in fact written by a Kentish man, Thomas Clarke of Canterbury, in the early nineteenth century and is called 'Cranbrook' after the place of the same name. It has been suggested that this is a fact that goes unacknowledged in Yorkshire. Local historian Frazer Irwin took issue with this and to rectify the situation proposed that a plaque should be placed on White Wells on Ilkley Moor in recognition of the origin of the tune. This was achieved in 2016 to coincide with the fortieth anniversary of White Wells reopening to the public and was unveiled on 16 May by Ilkley Parish Council Chairman Brian Mann; Francis Rook, Chairman of Cranbrook and Sissinghurst Parish Council visiting from Kent; a group of local singers to give a rendition of the song; and of course Frazer himself. Absent from the proceedings, though invited to attend, was the original critic of Yorkshire's ignorance.

The photo shows Frazer looking very pleased with himself that his plaque had come to fruition and that the facts are now fully acknowledged to dissuade any other critic of Yorkshire's imagined ignorance ... so there!

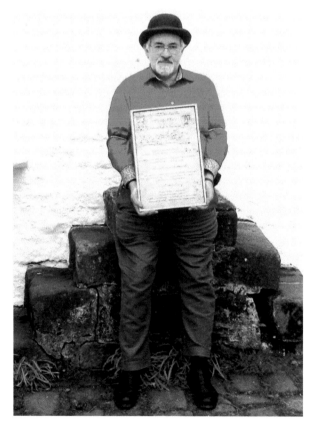

Frazer Irwin at White Wells with his 'Bah't 'At' plaque, May 2016. (Mark Hunnebell)

P

Panorama Reservoir

While work started on March Ghyll Reservoir to supply Otley, in Ilkley the council had also been considering improving water provision. Panorama Reservoir, much smaller than March Ghyll, was built between 1902 and 1904 on Ilkley Moor near the top of Heber's Ghyll. A filter house was built nearby in 1932 to comply with new laws covering water quality.

Councillors opening the impressive machinery in the new filter station, 1932. (*Ilkley Gazette*)

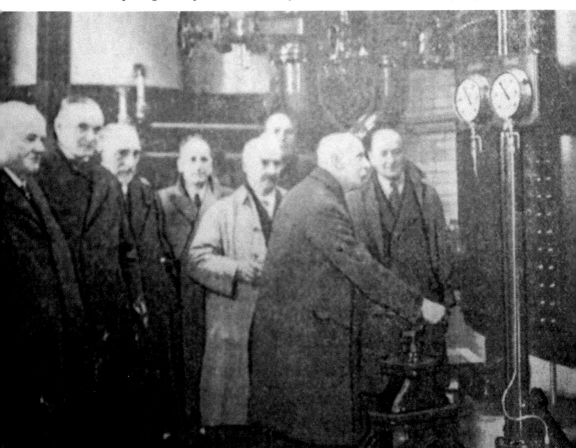

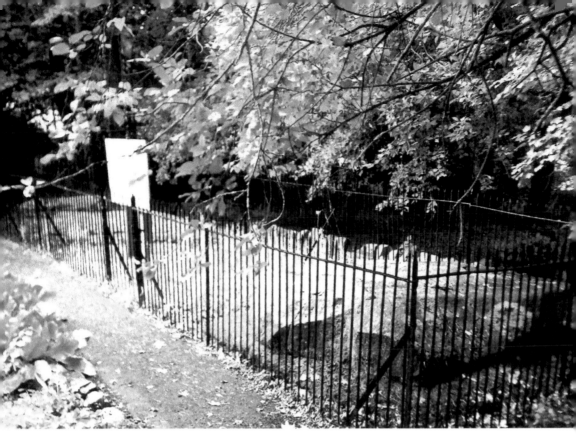

The Panorama Stones were moved to St Margaret's Park in the 1890s. (Mark Hunnebell)

Panorama Stones

In the early 1890s, fearing their destruction through quarrying, Dr Little arranged for the cup- and ring-marked Panorama Stones to be moved from close to the top of Heber's Ghyll and relocated in St Margaret's Park on Queens Road opposite St Margaret's Church where a protective railing was put around them. They can still be seen there today.

Paradise Park

Paradise Park is the name given to the small area of parkland between the Old Bridge and the Riverside Hotel. Previously this was an area of waste ground that attracted a significant amount of negative criticism. When it was put up for sale the name 'Paradise Park' was suggested as an ironic reference to the state the land was in – i.e., about as far removed from the notion of paradise that could be imagined. The land was duly purchased by the Ilkley Council and the Parks Department got to work and transformed the area into a much more pleasant place. It opened to great acclaim in 1911. In the autumn of 2021 a path was laid across the grass and a memorial stone was unveiled in 2022 to commemorate the local victims of the Covid-19 pandemic.

'Paradise Park' between the Old Bridge and the Riverside Hotel, Bridge Lane. (Mark Hunnebell)

Pawson's Cottages

Pawson's Cottages were built from money left in the will of Miss Susannah Pawson. Spinster Susannah and her younger sister Harriet (Agnes) had a small café popular with walkers and cyclists in their terrace house in Bridge Lane. Harriet died at the age of fifty-nine in 1943 and Susannah continued with the café until she died in 1947 aged sixty-seven. The *Gazette* described the sisters as 'Thrifty Yorkshire-women and were not regarded as being particularly well to do.'

Nevertheless Susannah left £9,000 in her will with the stipulation that land would be bought and as many houses as funds would allow be built. These would be homes for widows and spinsters aged over sixty-five, to live rent but not rate free, with preference given to Ilkley residents.

In the early 1950s land on the corner of Bridge Lane and Skipton Road was donated by Mrs Rycroft and in 1954 the first block of four flats, designed by Mr Skinner, who had also designed the Ilkley Lido in the 1930s, was opened. More flats were completed in 1956 following additional fundraising.

'Pawson's Cottages', built as a memorial with money from the family's will. (Mark Hunnebell)

Quarrying

Small-scale quarrying on Ilkley Moor had provided stone for buildings in the village from an unrecorded date. There was a quarry at Spicey Ghyll, though little evidence of the industrial activity undertaken here remains. A closer look reveals the areas excavated on both sides of the ghyll. There was another small quarry at the top of the moor on the skyline above White Wells. During the nineteenth century the 'Bull Rock' that stood near the Cow and Calf was used for building three houses in Brook

The disused Spicey Ghyll quarry with a grand vista to Upper Wharfedale. (Mark Hunnebell)

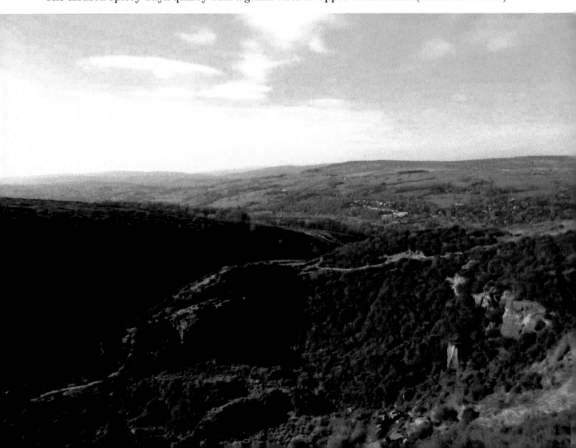

The lads of Hangingstone Quarry take a break, posing for the camera. (Sally Gunton)

Street and in the 1880s Hangingstone Quarry behind the Cow and Calf was expanded. By the start of the twentieth century the gradual destruction of the moor caused by quarrying was becoming a concern, so steps were taken to stop the activity and the quarry closed. A photograph from *c.* 1900 shows some of the men employed at Hangingstone Quarry, though unfortunately it doesn't record their names, or the name of their dog!

Rescue in Ravensdale

In 1946 the children's book *Rescue in Ravensdale* by Esme Cartmell was published. The story centres on a family holiday in the Yorkshire Dales immediately before the start of the Second World War. It concerns the family's efforts to help a German escaping from a Nazi spy pursuing him. Although the titular location is fictional the story describes visits to Ilkley and in particular the Lido, the Tarn and White Wells. The novel is perhaps best described as being 'of its time' – and unlikely to sit comfortably with the sensitivities of today; for example the parents are heavy smokers and think nothing of lighting up in the confines of the family car. Naughty!

Riverside Walk

The riverside footpath linking the Old, New and Suspension bridges was complemented with the creation of the Memorial Gardens and path improvements in the 1950s making a pleasant circular walk possible, following the route around on the northern side of the river back to the old bridge via the east and west Holmes fields, or with a detour through the woods.

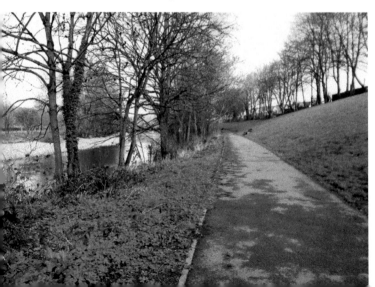

The riverside footpath between the New Bridge and the Suspension Bridge. (Mark Hunnebell)

In the 1970s I recall a miniature train operating to and fro along the southern fence of the Rugby Club, on the East Holmes Field on the north side of the river.

Rocky Valley

Rocky Valley has long been a familiar feature of Ilkley Moor, both as a playground among the younger citizens of the town and others enjoying pleasant strolls between White Wells and the Cow and Calf rocks.

In 1906 the *Ilkley Gazette* reported, rather indignantly, that a visitor to the area had made somewhat disparaging comments about the local hills having 'too much of a sameness and roundness about them to be impressive'. The paper stated that the gentleman in question had not passed through Rocky Valley 'otherwise he might have modified his expression considerably' and added,

> to walk through this wild mountain pass, so to speak, is as impressive as anywhere we are acquainted with, and if the gentleman favours rock climbing he can get as difficult bit of practice here as in the Alps, only on a very much more limited and circumspect scale.

While Rocky Valley cannot of course be compared with the passes in other high-mountainous regions of the world, it is nevertheless an atmospheric place, especially when a moorland mist descends. It is also as popular now for rock climbing as it was over a century ago. The rugged landscape of Rocky Valley does suggest a far more remote setting than what is actually the case and it continues to stir the imaginations of countless locals and visitors too.

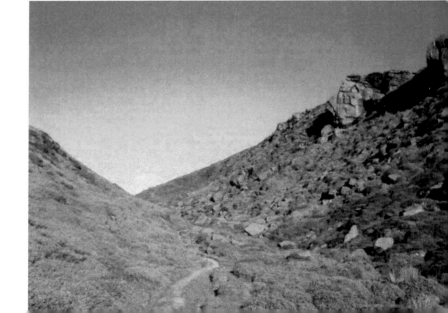

Rocky Valley feels remote despite only being a mile from town. (Mark Hunnebell)

Sea Spray at Ilkley

Being roughly equidistant from the east and west coasts, an article dating from 1911 concerning 'Sea spray at Ilkley' caught my eye. In November of that year the *Ilkley Gazette* reported,

> We have often heard it said that when a westerly wind was blowing over Ilkley Moor a damp handkerchief held windward, or even a dry one, if it happened to be raining, would collect particles of salt sufficiently numerous to give a distinct saline flavour to the handkerchief when touched with the tongue, and recent observations by Mr Albert Wilson, Ilkley, bear out this statement. The occurrence of a film of salt on glass windows, foliage of plants &c, has often been observed after severe gales in locations far removed from the sea, but do not appear to have any data recorded as to the exact amount deposited. The following may therefore be of interest.

There followed a description of observations, rainfall measurements and calculations that caused Mr Wilson to conclude 4,298 gallons of rain fell per acre containing 13lb 5oz (approximately 7 kg) of salt and 3.75 tons of salt per square mile. Mr Wilson observed that the wind of the recent gale had been blowing from a south-westerly direction – roughly the direction of Blackpool, though perhaps what Mr Wilson observed came from a lot further away than there. As we know winds from the Sahara often bring a layer of dust to parts of the UK bourn up on high-altitude currents and deposited far away. Could it have been something similar that Mr Wilson experienced?

I must add, to satisfy anyone who may be wondering, I once tested the hankey theory on Ilkley Moor and can't say that I noticed any distinct saline flavour when touched with the tongue!

Sewage Works

In the 1870s the Ilkley Local Board constructed sewage works on land adjacent to the river at Sandy Lands near to Beanlands Island. With the ever-increasing population

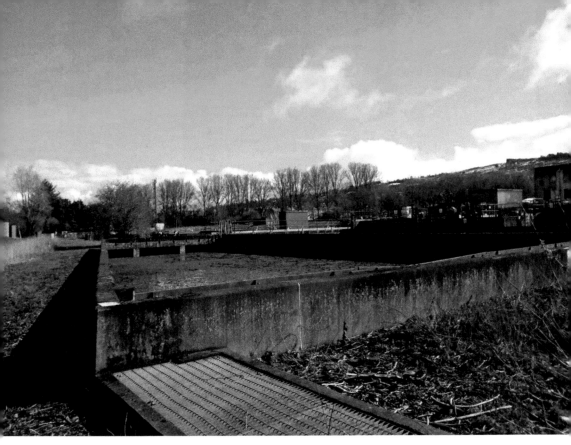

The sewage works on the riverside path between Ilkley and Ben Rhydding. (Mark Hunnebell)

'middens' were no longer practical and a better way of dealing with the town's effluent was required. The works have been expanded over the years to accommodate the town's growth. A 'refuse destructor' was added to the site in 1905 to incinerate the town's rubbish but it wasn't until 1938 that dustbins became compulsory, replacing ash pits.

Shops

The former shops of Ilkley are often the subject of nostalgia and debate, their names and locations being half forgotten until a chance remark brings back a memory from childhood or youth.

Shuttleworth's shop at the bottom of Brook Street on the row called Brook Terrace was one of the first larger shops to open in the town, selling all manner of items, but particularly stationery and souvenirs. The proprietor, John Shuttleworth, was also instrumental in establishing a visitors' guide to Ilkley, which in the 1860s evolved into the *Ilkley Gazette*. Shuttleworth's also sold a range of picture postcards featuring local beauty spots and popular places to visit in the area. Around 1870 Shuttleworth's moved into larger premises, Gothic House, newly built adjacent to Brook Terrace. Gothic House continues in retail use as Boots chemist.

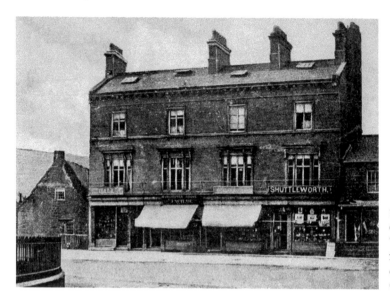

Shuttleworth's, one of the first 'modern' shops in Brook Street, early 1860s. (Sally Gunton)

Dividing the twentieth century into three broad eras, 1900s to 1930s, 1930s to 1960s and 1970s to 2000, breaks down into a general idea of what my grandmother would have been familiar with, what my parents were familiar with and what those of my generation remember – though of course there is quite a bit of overlap with each era. Sadly, time has overtaken the older generation, so first-hand accounts are lost – and some shops relocated to other premises. Evidence remains of former businesses. In 2023 the name 'Hampshire' (formerly 'Sunderlands') could still be seen on the gable end once abutting the railway bridge on the west side of Brook Street – a 'ghost sign'.

Brook Street *c.* 1910s. Even today 'Hampshire' can still be made out. (Mark Hunnebell)

Woolworths had a presence in the town for over seventy years. It provided employment in its various departments, from hardware to pick and mix sweets to records. Two of a row of three houses on the south-eastern side of the railway bridge were demolished in the 1930s to make way for 'Woolies'. When the firm closed its high street branches, the shop was converted into two smaller units, though the exterior façade of the building remains largely intact. This photo featuring some of the female staff at Woolworths was taken in 1954 and features my mum, Margaret Hunnebell (back row, third from left).

Busby's had a small branch of their Bradford-based department store in Brook Street between 1919 and 1969. Thirkell's butchers on Railway Road made pork pies that were an Ilkley institution from the 1930s until 1986; Clayton's pies in Brook Street were popular too. The older and middle generations would also cite Fox's pies on Leeds Road, and just the older generation would remember Dobson's Tripe and Cow Heel Shop, also on Leeds Road. In the 1960s some old shops on the east side of Brook Street were demolished and replaced with new buildings.

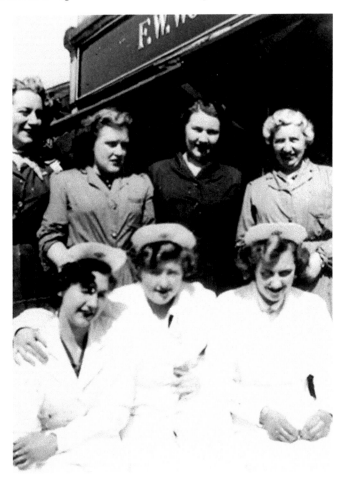

The Shop Girls –
Woolworth's staff pose
outside the store, c. 1954.
(Margaret Hunnebell)

Here's a name check of shops to bring back memories and start the conversation.

The household shop Mott's in Brook Street became the Thrift supermarket in the early 1960s; later the Fish Dish chippy, then renamed Gullivers and is currently Boots chemist. Burrell's next door sold dry goods, cheese and delicatessen – a wonderful 'old' shop, little changed since the early years of the twentieth century that in the 1970s and 1980s felt like a relic of another time. Burrell's also became part of Boots when the chemist relocated from the other end of Brook Street. Another chemist, Scott's, was situated in between Clayton's butchers and Halford's bakery on Brook Street. Halford's café was on West Street next door. Halford's became Sylvio's and the Gateway pub was above. When Sylvio's and the Gateway closed the premises became The Honest Lawyer pub and after that, Johnson's, also a pub, taking its name from that which the Gateway had formerly been known and remembered by the older generations. The new incarnation of Johnson's was enlarged into the former Scott's chemist and was a popular venue for music and dancing upstairs in the 2000s. Johnson's became Piccolino's restaurant, which remains at the time of writing.

Along the row between the Fish Dish and the traffic lights was Redman's grocers and Fred Trees greengrocers, which in the late 1970s became the Rockville ice cream parlour, introducing the youth of Ilkley to the delights of brightly coloured Slush Puppy drinks. Also around this time another dose of Americana was provided in the railway station with the Green Frog, a very popular hangout with teenagers and young adults, particularly on Friday and Saturday nights. The menu included the peanut butter-coated Snoopy Burger and the classic pud: hot chocolate fudge cake with ice cream. For me, partaking of the latter began the start of a happy relationship that has endured beyond that era and can transport the memory back to the 'Green Frog' when indulged in even now!

Other shops from the late twentieth century include the Regis café on the corner of Brook Street and Station Road. This later became a sandwich shop in one side and a hairdresser in the other. The building was demolished in the mid-1980s as part of the railway station redevelopment. Older residents will remember Clegg's electrical shop here in the 1940s prior to it moving to The Grove. Around the corner on Station Road was the Flower Box and on the station approach, The Wool Box, while buses arrived and departed from what is now the Station Plaza in front of the railway station. A snicket ran down from the Flower Box and behind the Regis, emerging in Brook Street by the zebra crossing, a convenient shortcut. Also in Brook Street was Vallances electrical shop on the corner of Railway Road selling and renting out colour TVs. They also sold a good selection of pocket calculators, the must-have gadget for school kids in the late 1970s. Vallances, now Costa Coffee, was previously occupied by the grocers Monkmans and Beanlands before that. Beanlands also had other branches in the town and one in Ben Rhydding. Further down Brook Street was Dickenson's newsagents and Mr Allinson's tobacconists, later Blockbuster video rental. My generation will fondly remember the growth of video rentals in the 1980s. Even many of the smaller newsagents and off-licences in the residential areas of town had a selection of videos

to choose from. In the early days of home video, the big debate was between VHS or Betamax formats but who remembers a third format, VS2000? And a fourth, laserdiscs, about the size of a vinyl LP record and the forerunner of the DVD? These are now also considered a relic in a world of hard drives and instant downloads. Allen and Walkers at the bottom of Cowpasture Road occupied two adjacent shop units on the ground floor of Sedbergh Chambers. This was also a well-established firm dealing in home electricals. The photo was taken shortly before work on the current Gin Lounge began and shows the former signage of the electrical shop above and the school uniform shop in the other unit on the corner.

On Railway Road was the Underground music shop, later Muffins tea room, more recently a Vietnamese and now an Italian restaurant. Next along, Hillards supermarket, where the Essoldo cinema had stood, became Sunwin House and now Boyes, and of course the aforementioned Thirkell's pork butchers, now also an Italian restaurant and opposite on the corner of Trafalgar Road Jeff Smith's barbers in a small annexe now converted back into residential use. Across Railway Road from Thirkell's was a convenient entrance up into the station via a slope and subway under the former Skipton line. This was blocked up during the redevelopment in the 1980s.

Back in Brook Street between the stump of the former railway abutment and Woolworths was Bubs stationers with an extensive range of greetings cards and pens, though not as extensive as that of Broadbent's on The Grove. Over the zebra crossing on the west side of Brook Street there was Boots chemist at the top and next door down, Ashe and Nephew's off-licence occupied the shop that was formerly the Ilkley

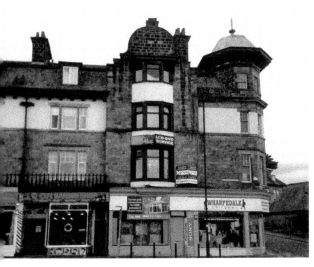

Above: Sedbergh Chambers at the bottom of Cowpasture Road. (Mark Hunnebell)

Right: The walled-up former entrance to the station via Railway Road. (Mark Hunnebell)

branch of Busby's. When the off-licence moved across the road into the new units in the 1980s, the Yorkshire Bank extended into the shop but more recently with the downsizing of banks and the closure of the Ilkley branch, the unit has reverted back into two separate shops. A little lower down the street there was a grassed area where the railway bridge had been removed by the bus shelter and a skateboard shop taking advantage of that craze in the late 1970s. This later became the Zipper jeans shop.

Around the corner from Brook Street and onto The Grove, under the glass canopy, was Anne's sweets and tobacconists. There was a delightful aroma from the pipe tobaccos to be enjoyed whilst ordering your quarter of sherbet lemons. Further along The Grove Broadbents deserves another mention. Their upstairs toy department was extensive and was rivalled only by Parkes way out on Skipton Road near the top of Middleton Road. Also on The Grove there were the shoe shops Clarke's, Freeman, Hardy and Willis and Tenants, Clarke's being popular for the requisite red sandals with shiny buckles – essential kid's wear for summer in the late 1960s and early 1970s. Oxfam moved into the shop previously occupied by Timothy White and Taylors chemists in the early 1970s. Prior to this Oxfam had been located in a wooden hut between the railway arch and the West Yorkshire bus garage in Cunliffe Road. The faded glory of the Bluebird café in the Spa Chambers on the south side of The Grove was modernised with the Kafe Konditori in the late 1970s, while Betty's café was as popular then as it still is today – and as it had been since the early twentieth century when it was The Kiosk Café.

Between Church Street and the bus garage on South Hawkesworth Street there was the somewhat dilapidated Arcade, brought back to life in the 1980s as The Victorian Arcade, and on the north side of Church Street the former Johnson's Dairy became the Queen Anne's Table restaurant in the 1970s. This too had something of a makeover in the mid-1980s and became the Mallard pub. There was Glovers car showroom on the corner of Bridge Lane, though older generations will remember this in its previous incarnation as the West End fish and chip shop. It is currently occupied by a Thai street food café. Along Bridge Lane, overlooking the allotments that were to become the Riverside Memorial Gardens Park, older residents will recall a clockmaker's shop, demolished in the 1950s. Back in Church Street they will also remember the famous ice cream shop next to the archway leading into Castle Yard. Mrs Stones ran this establishment until her death in the mid-1940s. Her ice cream was well known throughout the region and people came from far and wide to enjoy it. Unfortunately, her recipe was never revealed and its secret died with her. In the 1930s she had competition from Delucci, a mild-mannered Italian gentleman based in Skipton who came to Ilkley on his motor tricycle and visited the residential streets between the railway and the river. During the war years he was placed under internment and much missed by his regular clients.

There was also Mr Pegg's butchers on the south side of Church Street near the arcade and a newsagent on the corner with Hawkesworth Street. Older residents will also remember the Wheatsheaf pub on the corner of Church Street and New

Brook Street, demolished in 1961 and replaced with flower beds and benches. Down New Brook Street towards the river there was Chambers Garage in a large green hut overlooking the park. The building was demolished in 1978 and the area landscaped following the installation of a new sewer main. In 1983 the addition of the former Brook Street horse trough, originally dating from 1908, brought extra colour to the area as a flower planter. Across on the east side of New Brook Street, my grandmother would have remembered the row of shops being extended towards the river between the wars and the bus stop where the services to Otley, Leeds and Bradford started their journeys. From 1924 these were operated by the famous blue and cream buses of Samuel Ledgard. Residents in the years of the Second World War may also recall the nearby air-raid shelter on the open ground between New Brook Street and the passage into Weston Road and in New Brook Street, in the extended row, a small café, now the Shalimar take away. This was Mary's, popular with locals and visitors waiting for the departure of the Ledgards buses nearby – and the drivers of said buses having a brew, a slice of cake or a quick lunch between journeys. Pork pies were a popular menu item and were delivered from Fox's around the corner in Leeds Road. There was also Horace Thornton's electrical shop. Famous for his eccentricity, Horace was particularly noted for his thought-provoking window display comprising of an illuminated light bulb with no visible means of a power supply. Many of my generation will also remember in New Brook Street Myers greengrocers and an excellent Chinese restaurant which provided the first forays into foreign cuisine.

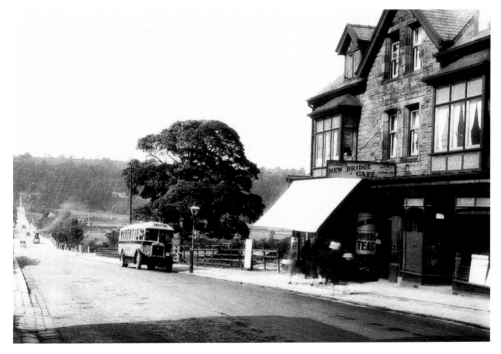

New Brook Street, early 1920s, before the row of shops was extended. (Sally Gunton)

Previously this had been the New Bridge Café, later Hilberts, that went on to operate a fish and chip shop – and later still Dales paint and decorating shop extended into the former Chinese. Now it's the Ilkley Cow restaurant.

Moving into Leeds Road there was another greengrocers shop, Dobson's, which opened late into the evening. Maypole, a forerunner of supermarkets (which moved into Brook Street in the 1960s), later became a car accessory shop with a coach booking agency, and next door a launderette. There was Dean's shoe shop and Mrs Barker's fish and chip shop on the corner of Weston Road. Opposite, on the other side of Leeds Road, once stood the Bay Horse pub, noted for its discreet after-hours lock-ins with no worries about the local constabulary – they were there! The Bay Horse was demolished in 1964, so by the time my generation were growing up this site was an extension of the Crescent Hotel's car park, since built on again and now a restaurant. Further along the south side of Leeds Road there was Easby's tailors and the parade of shops between Nile Road and Victory Road, which included Walker's newsagents and Wharfedale Cycles on the corner of Victory Road. There had been a cycle shop here for many years and during the 1930s local residents could have their wireless set batteries recharged here too. Between Victory Road and Little Lane, the parade of shops included greengrocers run by Brian Sherwin and later Harry Collier. In the middle of the row I recall a cobbler with a heady scent of glue wafting out of the door and my dad remembers Horace Slater's barbers also being on this row and, bizarrely, buying fireworks from a display in Horace's shop in the 1930s. Across on the other side of Leeds Road by the junction with Wharfe View Road was Mann's bakery, now a conservatory showroom, and Hothersall's hardware shop where paraffin could be bought by the gallon for domestic heaters. Back towards the town centre on the north side of the street there was Percy Drivers butchers, now Lishmans, Cree's pet shop, The Remnant Shop and Ronald Smith's TV and electrical rentals.

On the junction of Leeds Road with Little Lane was the Co-op shop, while those of my generation will recall this as Cooper's Furniture Hospital at street level and above The Minstrel's Gallery restaurant, later to become the legendary Il Trovatore nightclub, simply remembered as 'The Trav'. The nightclub closed in 2006 and in 2015, following an extensive refit of the premises opened as the fifty-six seat Ilkley Cinema with a second screen opening in 2018 with forty-two seats. This Tardis-like building appears smaller on the outside than what the clever use of space on the inside allows. The street-level shop remains too, currently in use as a soft furnishings retailer.

Along Little Lane there was Morgan's store, once Robinson's, an off-licence on the corner of Lower Wellington Road. This shop was also familiar to my grandma's generation as Tyzak's and later as Gill's in the 1930s – lads in the area ran penny errands for neighbours to fetch jugs of beer! It was known as 'the bottom shop' to many residents in the locality as opposed to the other off-licence, or 'top shop', run by Mr Willoughby in the 1930s and later Thornber's, on Railway Road between Nelson Road and Wellington Road. This is now Clegg's electrical shop, which moved here from The Grove.

The off-licence on Little Lane was familiar to generations of Ilkley youth. (Sally Gunton)

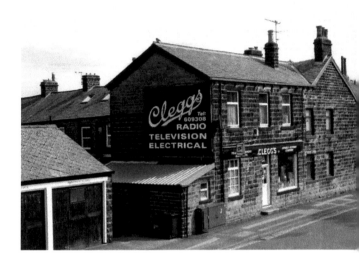

Likewise the 'top shop' on Railway Road, now Cleggs electricals. (Mark Hunnebell)

Also on Little Lane there was a butcher's. This later became a CB radio shop, Citizen's Band radio being a popular hobby in the early to mid-1980s before the advent of the internet, smart phones and social media. CB required an operator's licence and the transceiver sets became a feature of many bedrooms and cars across the country. The working range of the radios was generally somewhat limited, being mostly confined to the local area, so the chances were that you knew who you were conversing with despite the names adopted by users. It was an unwritten rule that you transmitted under a pseudonym. Consequently, colourful appellations were adopted, such as Airwolf, Nightrider, Firefox or some other daft handle, perhaps conveniently borrowed from popular American films or TV shows of the era and often implying a macho menace that the user didn't actually possess.

I didn't have a CB 'rig', so I could never have a meaningful conversation about the length of my 'dipole' or the power of my 'firestick', or indeed debate if such were even legal. For those that were au fait with the coded newspeak of CB, such conversations conveyed an air of rebellious pride amongst those who were in on the secret.

Also on Little Lane there was a hairdresser at the bottom of Mornington Road and an off-licence on the corner of Brewery Road; and on North Parade there's still a fish and chip shop.

There were many other shops, off-licences and newsagents dotted throughout the residential areas of the town that will be remembered from the later decades of the twentieth century that have now since closed. Here's some more I recall.

Greengrocers shop in Middleton Road. The end terrace shop on Bridge Lane overlooking the park (this had been the Pawson sister's café in the 1940s). Small shop on Cowpasture Road, popular with grammar School pupils for break-time snacks, as was the sweet shop opposite the school's bottom gate on Springs Lane. Also on Springs Lane, a chemist opposite the Health Centre and Station Garage next door. A health food shop at the top of Brewery Road. An off-licence at the junction of North and East Parade. An off-licence on the corner of Dean Street and Leeds Road, known more latterly as 'The Grog Shop'. A newsagent on the corner of Leeds Road and Leamington Terrace. The sub-post office on the corner of Leeds Road and Ash Street. An antique shop on the opposite corner that had a model lighthouse in the front window; this shop later became a travel agency and has since being converted into residential use. Older generations will remember this shop as a café. Around the corner there was another off-licence on Ash Grove and on the corner of Bath Street and Leeds Road was a small wooden hut selling model cars and train sets. Since the publication of *Secret Ilkley*, Grandad Nichols' chippy opposite Thwaites Avenue has now become Midgeley's.

Moving further down Leeds Road and towards Ben Rhydding, there was the Lakeland Laundry opened as the Sanitary Laundry at the end of the nineteenth century. In the late 1970s this became Peter Blacks sportswear – since demolished and replaced with housing. Further down on the opposite side was the Wharfedale Gate pub, now also replaced with housing and a wool shop opposite Valley Road. There was a fish and chip shop, later a Chinese take away, opposite Colbert Avenue and a newsagent a few yards further along. Nearby was Hammonds furniture shop, now a fireplace showroom. The petrol station is still there while the adjacent hairdressers is now a florists and the former greengrocers a little further is now a laundry. The old Ross Bros car showroom at the junction of Wheatley Lane is now The Original Factory Shop while the adjacent petrol station survives. The Complete Runner sports shop remains on Sunset Terrace and the Hollygarth Club continues nearby. The original club occupied premises in a house on the north side of Leeds Road, near Colbert Avenue. By the 1960s the club was looking to expand and in 1964 approached the Ilkley Council with a view to building a new clubhouse on the former Ilkley Grammar School playing field. Permission for this wasn't granted, though the IUDC did agree to work with the club to find alternative provision. This came shortly afterwards when the former Co-op a little further down Leeds Road became vacant. The Hollygarth moved into this building, where it remains today, having undergone various extensions and modifications over the years since. The former Grammar School field adjacent to Valley Drive was used instead for the construction of the International Wool Secretariat, opened in 1968.

On Valley Drive the parade of shops comprised of an off-licence, a hairdresser, a greengrocers and a launderette. The off-licence remains while the hairdresser closed

Right: The Hollygarth moved into the former Co-op premises in the mid-1960s. (Mark Hunnebell)

Below: The shops on Valley Drive. (Mark Hunnebell)

and the launderette was more latterly conservatory showrooms with the greengrocers in between, now converted into residential use – though during the compilation of this book the conservatory showrooms have also now closed and the former hairdressers is the Happy Valley Café.

There may be others I have missed, so apologies for any omissions. Space won't allow mention of every business past or present, but hopefully you have been on a journey of reminiscence with me as you read this section.

Sparrow Park: An Update

In my book *Secret Ilkley* I asked the question Where is Sparrow Park? (p. 95) The answer, based on a comment made in 1937 by Councillor Dr Whitfield, is the triangle of land at the junction of Wheatley Road, Bolling Road and Springs Lane. However, another claimant to the title has recently come to light, this being the small green on Wheatley Lane in

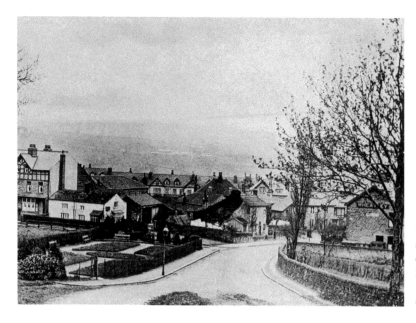

Sparrow Park at the bottom of Conker Hill, Ben Rhydding, c. 1920. (Sally Gunton)

Ben Rhydding, diagonally opposite the Wheatley Arms Hotel. Perhaps the former gave its name to the later, or maybe Dr Whitfield had simply confused Wheatley Road with Wheatley Lane. Either way the Ben Rhydding 'Sparrow Park' survived until after the Second World War. At the time of writing plans were afoot to revive this forgotten park into an accessible open space with new benches for all to enjoy once again.

Spectre of the Brocken

A somewhat elusive natural phenomenon was reported on in the *Ilkley Gazette* in February 1913. Often associated with mountainous regions, it can occasionally be seen given perfect conditions more locally here in Wharfedale, usually during the winter months. The article stated as follows:

> Spectre of the Brocken. A mirage on Ilkley Moor.
>
> Most of our readers will know something about 'The Spectre of the Brocken', an optical illusion or mist halo associated with the highest summit of the Hartz Mountains in Prussian Saxony. Thousands of tourists visit the district for the purpose of seeing the spectre, though occasionally such a phenomenon is to be seen very much nearer home, and now and again on our own moor.
>
> During the last forty years Mr T.C. Gill, the Ilkley Moor Ranger, has seen a similar spectre or mirage on Ilkley Moor nine or ten times; the last occasion being on Wednesday week.
>
> Mr Gill was walking from Willie Hall Spout along the new road to the Old White Wells, at 10.15 in the morning. The fog was very thick in the valley, and came up to his

The spectral shadow of Ilkley Moor cast onto mist across the valley. (Mark Hunnebell)

feet, but above it was perfectly clear and the sun was shining brilliantly. He stood and looked over the valley, and saw his shadow thrown across the fog to the length of about 80 yards (approx. 73 m) from head to foot. The image was six or seven yards across, but somewhat out of proportion, owing to the angle at which the sun was shining. His ordinary shadow, away from the fog, was from 10 to 15 feet long (approx. 3 to 4.6 m).

Morning mists create a ghostly atmosphere on the moor, with trees taking on a spectral appearance and the shadow of the moor cast onto low cloud across the valley.

Spence's Gardens

The land for this was gifted to the town in 1895 by Dr W. M. Spence and the paths alongside the stream planted with trees and shrubs. The gardens were enlarged in 1901. The council installed a metrological station and the data collected often appeared in the local press. Although the weather station is now long gone, Spence's Gardens continue to provide a peaceful refuge on the edge of the town centre.

The view of Spence's Gardens before the trees reached their present maturity. (Sally Gunton)

Stepping Stones

The stepping stones have been repaired and replaced many times over the years and when the river is low during the summer months it is still possible to make use of them – though not to be recommended when the river is fast flowing! Indeed, during the winter months the water level of the Wharfe is sometimes above the stones and they cannot be seen. This often results in some of their number being washed away.

Crossing the Stepping Stones in winter is a daunting prospect! (Mark Hunnebell)

T

Toboggan Slide

In 1906 the Ilkley Council debated improvements to the toboggan slide on Ilkley Moor that had been in place since 1903. Many present-day sliders are probably unaware the run still in use dates back to the early years of the twentieth century.

The former moor toboggan slide is still apparent after snowfall. (Mark Hunnebell)

Toll Bridge

Opened in 1887 by the Denton Hall Estate to replace the previous ferry service, after sixty-two years tolls ceased in 1949 when the Ilkley Council bought the bridge for £400. A change of name was suggested; however, more than seventy years after the last paid crossing the structure is still known as the 'Toll Bridge'. In 2022 suggestions were made to construct a new crossing adjacent to the Toll Bridge – time will tell if this comes to fruition.

Although crossing fees ceased the bridge is still called 'The Toll Bridge'. (Mark Hunnebell)

U

UFOs

Over the years strange lights in the sky have been reported above Wharfedale as elsewhere. Usually there is a rational explanation, though the reports often make sensational reading. In 1931 one was seen at around half past midnight early on Christmas Day by an observer on Bolling Road. When reading the report I must confess I thought the punch line was going to involve a sighting of Santa Claus doing his rounds but refreshingly it didn't. The witness said this of the event:

> At the first second I thought it was a flash from the big headlights of some motor car, but looking round I saw overhead what looked like a bar of light which moved across the sky and disappeared over the hills above Middleton. It moved much more slowly than a shooting star, it lit up the whole countryside for a second or two, and certainly could not be called a ball of fire.

The witness was sober and it was also ruled out that what he had seen was lightning or the Northern Lights. A few years later in August 1936, another event was witnessed, reported all over the country of a large bright ball of light travelling slowly north in the summer sky. A similar sight occurred in 1971 when a local resident spotted a bright light, initially in the north and then a little later in the western sky. This too was reported nationally.

After the concept of 'flying saucers' had caught the imagination in the late 1940s, UFO sightings became more common and with the idea that maybe such lights were something more than natural phenomena. In the 1980s a famous case occurred on Ilkley Moor involving a retired policeman. (Why does it always seem to be police officers?) He claimed to have seen an 'alien being' walking around on the moor and when he got back into town he had 'lost' some time, in that it was around an hour later than he thought it was, giving rise to the theory that he had been abducted and taken aboard an 'alien spaceship'.

There have been other reports of strange lights in the skies around Ilkley, particularly red, green and flashing white ones. Perhaps Wharfedale's proximity to Leeds-Bradford airport hasn't always been taken into account!

An interesting phenomenon can be observed, usually during the summer months, when the sun is not far below the northern horizon at night: noctilucent clouds. This is both strange and beautiful, caused when sunlight from below the horizon is reflected off ice crystals high up in the atmosphere creating a bright light in the sky.

Seen from Ilkley Moor, noctilucent cloud illuminates a summer night's sky. (Mark Hunnebell)

V

Dickie Valentine Visits Ilkley

A charity 'midnight matinee' was held at the Essoldo cinema in November 1957 organised by the Ilkley Round Table in aid of White Windows, the West Riding's Cheshire Home.

The film shown at the event was *An Affair to Remember*, but the big attractions were personal appearances by the Gaunt Brothers, popular TV stars of the day, and the singer Dickie Valentine. He had started out singing with the Ted Heath Band but went on to find fame as a solo artist in the mid-1950s. Consequently the auditorium of the Essoldo was packed to capacity with such a big name coming to the town. My dad, one of the projectionists at the cinema, recalled the event:

> Dickie Valentine was very good. He ran over his time on stage but came up to the projection room and brought a large plate of sandwiches for the three of us on duty that night, Alan Parkinson, George Perry and of course myself. Dickie had a nice chat with us and left with a smile having apologised to us for being late with his performance, but with over a thousand people cheering him on, we didn't mind.

The night was a resounding success, particularly for dad's youngest sister, Brenda. She had seen Dickie Valentine in Blackpool the previous year and managed to get a photograph with him. When he came to the Essoldo Brenda caught up with him again and asked him to sign it. He duly obliged.

Incidentally Dickie also knew a thing or two about the alphabet: he'd had a festive number one with *Christmas Alphabet* in 1955.

The New/Essoldo cinema often hosted special events. One of the earliest was a BBC broadcast in January 1931 featuring the Bradford City Police Military Band and Choir. Concerts on the cinema organ were well attended too, including performances by well-known organists of the era such as Henry Croudson, who also played at the Blackpool Tower Ballroom. My dad also recalls the following:

> People often chat to me about their recollections of the New Cinema and many remember Mr Gledhill and later, as the Essoldo, Alan Parkinson who used to play our theatre organ,

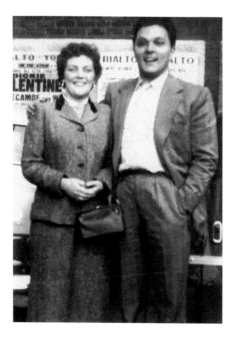

Auntie Brenda poses for a 'snap' with Dickie Valentine in Blackpool, 1956. (Brenda Lawson)

though I sometimes have to put them straight about one important detail. Contrary to popular belief, the cinema organ did not come up through the floor. Instead it was a permanent fixture at the side of the stage in front of the screen. This is simply a matter of confusion with the large cinemas in Leeds, where in some cases the organ did indeed rise up majestically in front of the audience. A common misconception that I have spent countless conversations trying to correct over the years since the Essoldo closed!

VE Party, Wellington Road

During the days and weeks immediately following VE Day (8 May 1945), many streets in Ilkley held parties for the residents of the area. In Wyvil Crescent two parties were held one at each end of the road on 9 May, and there was also a party in The Crescent off Colbert Avenue. Another party for the children of the Cowpasture Road area was held in the garden of Myrtle Bank.

The party in Wellington Road was held on Whit Saturday, 19 May 1945. In the following edition of the *Ilkley Gazette* a photo of it taken from the southern end of the street was printed. On the same page of the paper further information is given about the Wellington Road street party:

A 'Victory' cake made, and iced by Mrs Clarke, was cut by the oldest lady of the Wellington Road district, Mrs Britton, at a street party to celebrate VE Day on Whit-Saturday. Eighty children sat down to tea at a loaded table, and parents and helpers comprised the second sitting. The road was decorated with flags and bunting, and

coloured lights formed the letters VE in the middle of the street. Children and adults took part in races during the afternoon, and prizes of savings stamps were awarded.

Afterwards the street was flood-lit for dancing, and the party came to an end with the singing of 'Auld Lang Syne' and the National Anthem. Sgt Elder and Mr C. Clarke were responsible for the illuminations, and the catering was in the hands of Mrs Brooks, Mrs Clarke, Mrs Tipping, Mrs Fletcher, Mrs Brayshaw, Mrs J. Keenan, Mr Hall, Mr Brooks and Mr Morgan.

My dad also appears in the photo and provides us with an account:

I was called up into the Army shortly after my eighteenth birthday in September 1944 and joined the Duke of Wellington's Regiment. We underwent rigorous training and by the spring of 1945 I was with the 50th Division billeted in Skipton waiting for orders to head to Germany for the 'final push' into Berlin. The war was nearly over according to the news. May came and on the 8, while our unit was still in Skipton, the surrender of the German forces was announced and Britain went wild with celebrations. There was dancing in the streets in Skipton and all the army lads around town were invited into peoples' homes to have drinks. A few days after VE Day I managed to get a pass so I could come home to Ilkley in the afternoon for the VE party in Wellington Road where my family lived. This was held on 19 May, Whit Saturday. The street had been decorated with flags and bunting and everyone was in their best clothes. The kids had a marvellous time with games in the street and on a long table set up in the road, buns, cakes and sandwiches which everyone contributed to from their rations – and more besides! Unfortunately I had to get back to my unit in Skipton in the evening so missed the continuing celebrations for the adults that night. That's me right at the back of the photo, with my Duke of Wellington's Regiment uniform on. The lad four to my right, your left as you look at the photo, is my cousin Dennis Smallwood in his RAF uniform. Dennis was a few years older than me and had been called up early in the war. He had flown many bombing operations and was one of the lucky ones to survive. As we know the war continued for another three months until August 1945 and we were very much aware of all the lads still fighting in the Far East. They are often called 'The Forgotten Army' because they missed the party and were still in the thick of it out there. But they weren't forgotten, at least not by their families here at home or by us in the services. As for me, I wasn't posted to Germany or the Far East. Instead I was sent with Y Platoon to Egypt and Palestine in 1946, but that, as they say, is another story …

With a 'loaded table', the residents had pooled their rations and procured other items from undisclosed sources. The authorities turned a blind eye, temporarily, to all the various celebratory proceedings – or somebody forgot to tell them!

The North Parade, East Parade and Dean Street residents held their celebrations in the Leeds Road Methodist Schoolroom on 22 May.

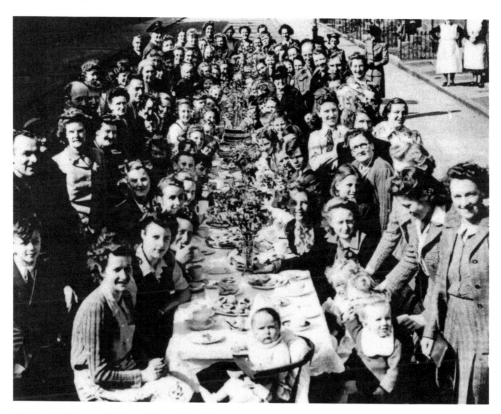

Victory in Europe being celebrated with a street party in Wellington Road. (Edwin Hunnebell/ *Ilkley Gazette*)

W

War Memorial Gardens (The Park)

Following the Second World War thoughts turned to various memorial schemes: houses for ex-servicemen, a Memorial Hall or a Memorial Garden. A public vote was taken and the idea of a Memorial Garden was the preferred option. Laying out the park was undertaken in the 1950s on the site of former allotments and in 1955 the project was complete, though there was no grand opening ceremony. Generations have since used the park for exercise, recreation and ball games. The children's playground equipment was replaced in 2022 and a free public petanque court was also installed in the park.

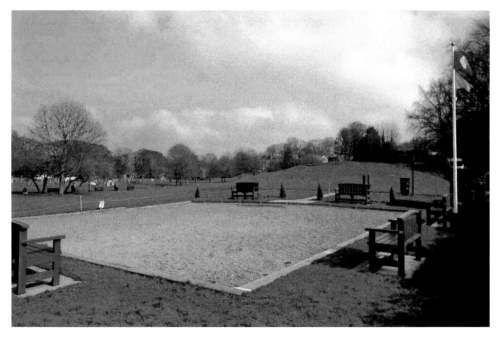

The petanque court and Riverside Memorial Gardens – commonly known as 'The Park'. (Mark Hunnebell)

West Rock – the prominent cliff below the cairn on Ilkley Moor. (Mark Hunnebell)

West Rock

West Rock is the name of the prominent cliff overlooking Rocky Valley on the moors. The whole range of cliffs across this part of the moor is given the collective title 'Ilkley Crags'. There are steps up to the top of West Rock, giving spectacular views across the Wharfe Valley and beyond.

White Wells New Year's Day Plunge

Following the transfer of White Wells from Bradford Council's Libraries and Museums to the Countryside Service in 1994, the New Year's Day Plunge was started on 1 January 1995. The event attracted only a few participants and was repeated the following year. The Plunge captured the public imagination and has continued to be an annual fixture in the town's calendar – with the exceptions of 2021 and 2022 due to Covid-19 restrictions.

After a full day of plunging the water is cloudy and it is impossible to see the bottom of the bath, a contrast to the usual crystal-clear water visitors are familiar with. The 1 January might be the best day of the year to go in, but 2 January is probably the least appealing day of the year to plunge! Though after draining and a brisk scrub around the bath, it fills up again with clear water and normality is restored.

The White Wells plunge bath ... before and after New Year's Day dippers! (Mark Hunnebell)

Willy Hall's Spout

The waterfall that flows over the White Wells access track has long been known as Willy Hall's Spout, though there is a degree of uncertainty as to who 'Willy Hall' or 'Willy How' actually was. Whether he was a real person, perhaps a local landowner or farmer, or whether it is a corruption of an earlier pronunciation is lost in the mists of time. What is known though is that the waterfall was considerably altered at the beginning of the twentieth century when the access track was built in its present location. There were complaints that the former ravine had been spoiled forever.

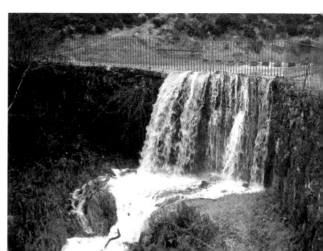

'Willy Hall's Spout' transforms into a gushing torrent after a storm. (Mark Hunnebell)

Windsover Camp

In the 1920s the Leeds Elementary Schools' Athletics Association established a summer camp at Ben Rhydding for city children to come out into the countryside for health and holidays. However the land was needed for council houses, so the Leeds Education Committee took over the organisation of the camp and relocated it to Windsover Farm at Middleton. It was very popular and in 1930 over 2,000 youngsters visited the camp between May and September for the sum of ten shillings each a week. As the eighteen-week season drew to a close in September a report of the camp appeared in the local press:

> For the final week there were 109 boys and girls in camp, and that their lungs had rather improved than otherwise by their stay at the camp was amply demonstrated when one of the teachers called for three cheers for the cook. As the ringing echoes died away, someone said 'and now three cheers for the school' but the boys only gave a long-drawn 'Aw –w-w!'. For once the girls had nothing at all to say, but they made a happily chattering band as they carried their laden kit-bags across the field to the waiting buses. About half a dozen members of the permanent staff were left behind to clear up the camp's affairs before finally closing down at the end of next week.

It was felt that the summer camps were of very great benefit to the children of Leeds. In camp they ate well and engaged in outdoor pursuits, games and classroom activities including nature study, sketching, and local geography and history lessons. Mr Bouch, in charge of the camp, was keen to point out the benefits: 'Even within the week they are increasing in weight and you can see them becoming more healthy and more active. The colour comes into their cheeks even after a wet week.'

In 1936 the camp relocated to Langbar.

There was a similar holiday home for youngsters at Highfield near the Cow and Calf Rocks on Hangingstone Road.

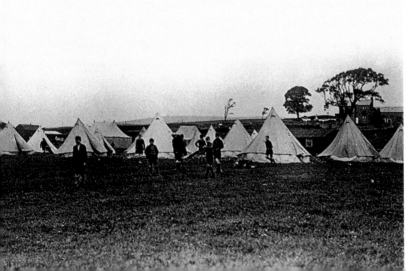

The summer camp at Windsover Farm in the 1930s. (Sally Gunton)

X

'X' Marks the Spot

Or in this case the 'X' appears as a cross. (Please forgive my artistic licence; I didn't want the 'X' section just to be the inevitable reference to medical equipment at the local hospital.) The symbol marks the entrance to the Seven Chambers Cave on Ilkley Moor just below Rocky Valley and a little south of the copse of trees to the west of Backstone Beck. The Seven Chambers isn't a true 'cave'; unlike some of the limestone caverns elsewhere in Yorkshire it isn't formed of subterranean passages created by water erosion. Rather it is a series of spaces underneath fallen gritstone boulders. For

The entrance to the 'Seven Chambers' below Rocky Valley, Ilkley Moor. (Mark Hunnebell)

generations of Ilkley children though the Seven Chambers has been a great place to hide on the moors.

X-ray Equipment

During the First World War the Ilkley Convalescent Home overlooking The Grove was re-equipped for war purposes and became the Ilkley Auxiliary Military Hospital under the control of the Beckett's Park Hospital in Leeds.

Fundraising was undertaken by Dr F. J. Stansfield in the Ilkley and district and approximately £500 was raised for X-ray equipment to be installed at Beckett's Park. After the war, at the annual general meeting of Ilkley's Coronation Hospital in 1919, it was announced, 'It has now been decided that the X-ray apparatus at present in use at Beckett's Park Hospital, Leeds, should be taken over by the Ilkley Coronation Cottage Hospital when no longer required in connection with the treatment of cases.' It was acknowledged that building work would be required at the Ilkley hospital to accommodate the equipment and that it would be presented perhaps in a 'year or two'.

By 1921 the expenses of building an extension to the hospital were proving a hindrance to the plan but appropriate provisions were soon put in place. The following year it was proudly reported 'Early in 1921 on the strong recommendation of the Honorary Staff, it was arranged to put up a substantial partition at the east of the male ward, thereby providing a suitable room for the apparatus as well as a darkroom'. Along with the apparatus the committee received a sum of £133 11s 5d. The balance left over from the original purchase of the equipment used 'to provide electrical and other accessories which were required'. Eventually an extension was built onto the east wing of the hospital and in later years, when funds allowed, the X-ray equipment was upgraded. In 1935 for example £250 was spent on a 'more modern appliance'.

The Coronation Hospital still has an X-ray facility today as part of the outpatients' department.

Y

YMCA Hut Roof Collapse

In the early years of the Second World War the YMCA opened two huts for use as canteens in the town. One was situated in the Victoria Avenue area while the other, opening in 1942, had a more central location behind the Spa Building on The Grove. After the war the Victoria Avenue hut was moved to the central car park where for twenty years, from 1948 until 1968, it served as a children's clinic. The hut behind the Spa was earmarked for relocation to Little Lane where it was intended that it would be used as a youth club. unfortunately, during the 'winter of '47' the accumulation of snow on the roof was too much for the structure and it gave way. The Youth Club

The YMCA hut roof caved in under the weight of snow, 1947. (*Ilkley Gazette*)

later moved into Mornington House in 1949 following the British Legion's move from there to Wells Road.

York Minster

Many people are surprised to hear that York Minster can be seen from Ilkley Moor. The cairn above Rocky Valley and West Rock provides a good vantage point and the Minster can be spotted from the Cow and Calf too. Perhaps counter-intuitively the winter months provide the best opportunity when the air is cold and dry. A small pair of binoculars prove ideal, though it can just be made out with the naked eye. The Minster is approximately 30 miles distant in a direct line, slightly to the north of due east.

It is also possible, looking in a north-north easterly direction from the cairn, to see the 'golf ball' radar domes at Menwith Hill alongside the A59 Skipton to Harrogate road and in the far distance beyond the wind turbines, the White Horse at Kilburn on the Hambleton Hills. Again crisp clear conditions are best.

The Minster dominating York can also be seen from distant Ilkley Moor. (Mark Hunnebell)

Z

Zebra Crossings

The area formed by the top of Brook Street, where the horse-drawn cabs had stood, and the fountain at the bottom of Mill Ghyll was previously known as Station Square. As motorised transport became more commonplace in the twentieth century traffic control measures evolved too, both to ease congestion and to safeguard pedestrians. (My grandmother, Clara Hunnebell, it will be recalled from a previous entry who was knocked down by a car in Brook Street in 1917, would doubtless have welcomed the improvements made over the following decades.) In the early 1950s the refuge familiar to us today replaced the previous circular island.

On October 31 1951 national regulations were introduced to assist pedestrians in crossing the road at points not controlled by traffic lights or the police – also with a view to reducing the considerable number of crossings on the road network and focus pedestrians into crossing at fewer but better-defined designated points instead. Crossings had up until then been marked with metal studs in the road and from 1934 some with Belisha Beacons as well. The new innovation involved painting lines on the carriageway. Locally the public were informed:

> The marking of crossings not controlled by traffic lights is a pattern of black and white (zebra) stripes in addition to the studs and beacons. Local authorities were recently asked to remove some two-thirds of the existing uncontrolled crossings, and some members of the Ilkley Council voiced a protest concerning this at their last meeting. The Ministry of Transport believes that the new 'and simpler' regulations and the reduction in the number of crossings will inspire all road users 'with a respect for and confidence in the whole crossing system which up to the present has too often been lacking'.

It was also stated that traffic would not be allowed to park within 45 feet of the approach side of the crossing. The zigzag white lines were not introduced at zebra crossings until 1971.

The island at the top of Brook Street, with only minor modifications over the years, has now been in place in the town centre for more than seventy years and the crossing duly evolved into a 'zebra'.

White lines added to crossing points created the familiar 'zebra' pattern. (Mark Hunnebell)

Z Training

Ilkley has had a long association with the military, from 1873 when a large camp was proposed to be sited on top of Ilkley Moor, though ultimately decided against, to the Boer War which saw local men heading off to distant lands. Then there were the training camps that became a familiar sight during the summer months in Ilkley in the early years of the twentieth century and of course the First World War during which many local men went to the Front. The Second World War too saw large numbers heading off in the service of their country and for the civilian population the concept of 'total war' was a frightening prospect as Britain indeed faced its 'darkest hour'.

During both world wars and National Service many local men were recruited into the ranks of the Duke of Wellington's Regiment. The photo shows some of the First Battalion of the Regiment at Catterick Garrison. Most on this photo had been demobilised a few years earlier from post-Second World War service in Palestine, Egypt and Sudan, including Ilkley man Edwin Hunnebell (back row, left to right, directly in front of the second of the two prominent men at the rear). They were recalled during the Korean War (1950–53) to undergo 'Z Training', effectively a refresher course in

fitness, weapons training and unarmed combat ahead of an anticipated deployment to the Korean peninsula. Fortunately a ceasefire was agreed and they didn't have to go. However after training exercises on the Yorkshire Moors around Catterick, these are the lads that drank the Tan Hill Inn dry!

1st Battalion, Duke of Wellington's Regiment, at Catterick Garrison, during 'Z-Training'. (Edwin Hunnebell)

Acknowledgements

As always, I wish to express my thanks to all the staff at the Ilkley Library for their assistance and patience while I researched this book in the local studies archive and typed up the manuscript on the public computers.

Thanks again must go to Sally Gunton for the use of photographs from her amazing collection. To the best of my knowledge and belief all of Sally's photographs reproduced in this book are free of copyright restrictions and have been included in good faith. However, mistakes can happen and I profoundly apologise if anything has been inadvertently overlooked. Thanks are due to the helpful staff in Boots chemist for their patience while I used the digital printer to produce hard copies of many of the images from memory cards and sticks – not a quick process with so many images to contend with! And thanks also to Northern Railways for permission to photograph the distance marker in the station.

Of course, the *Ilkley Gazette* cannot be thanked enough too, for the use of photographs and the reproduction and quotations used from articles in editions past. This newspaper is not only relevant in the present but also will be valuable to future generations looking back at a weekly snapshot of the town – just as the old editions have been for me.

And the good folk at Amberley Publishing who have made this book possible.

I am also greatly indebted once more to my parents, Edwin and Margaret Hunnebell, for their anecdotes and recollections of their lives in Ilkley. Although I've heard the stories many times before, their memories, gained from first-hand experience with all the feelings and emotions this entails, provide an added human dimension. This book gives me the opportunity to share their stories with a wider audience.

Finally, as ever, to my partner Joanne Everall, thank you. Yes I know, the pile of paper just keeps growing!